THE GREAT FIRE
OF
PETERSBURG
VIRGINIA

THE GREAT FIRE
OF
PETERSBURG VIRGINIA

TAMARA J. EASTMAN

Published by The History Press
Charleston, SC
www.historypress.net

Copyright © 2016 by Tamara J. Eastman
All rights reserved

First published 2016

Manufactured in the United States

ISBN 978.1.46711.866.8

Library of Congress Control Number: 2016930875

Notice: The information in this book is true and complete to the best of our knowledge. It is offered without guarantee on the part of the author or The History Press. The author and The History Press disclaim all liability in connection with the use of this book.

All rights reserved. No part of this book may be reproduced or transmitted in any form whatsoever without prior written permission from the publisher except in the case of brief quotations embodied in critical articles and reviews.

This book is lovingly dedicated to the resilient citizens of the great city of Petersburg, Virginia.

CONTENTS

Foreword, by Henry Kidd — 9
Acknowledgements — 11
Introduction — 13

1. WELCOME TO PETERSBURG! — 19
 Communities — 21
 Tobacco—The Chief Product — 24
 Slaves — 25
 First Free Black Community in the United States — 29
 The Market Square — 32
 Educating the Young — 32
 Apprentices — 36
 The Business of Birthing — 37
 Orphans — 37
 A Visit to the Business District — 38
 Entertainment — 42
 Crime and Law Enforcement — 43

2. THE GREAT FIRE! — 51
 Sunday in the City — 51
 The Day of Rest — 52
 A Great Calamity — 53

CONTENTS

3. THE IMPACT OF THE FIRE 57
 A Prosperous City 57
 Important Exports 58
 A City of Culture and Prosperity 59
 Devastating Losses 59

4. RISING FROM THE ASHES 61

5. MOVING TOWARD THE TWENTY-FIRST CENTURY 67
 Petersburg's Revival 67
 Interstate System 71
 Electrifying Progress 72
 The Siege of Petersburg 72
 Higher Learning 75
 The Freedmen's Bureau 76
 Separate but Equal 76
 A Retail Renaissance 77
 From Boomtown to Ghost Town 78
 Business Booming Once More 78

Appendix 81
 Prominent Families 81
 Slave Database in Petersburg in 1815 86
 Neighboring Plantations in 1815 88
 List of Businesses and Homes Destroyed in the Fire 89
Bibliography 95
Index 97
About the Author 105

FOREWORD

The look and charm of old town Petersburg that attract tourists and movie makers, like Steven Spielberg, can be directly traced to a fire that devastated the city in 1815. The mention of old town conjures up images of narrow cobblestone streets bordered by nineteenth-century brick businesses and restaurants. However, Petersburg once looked much like Williamsburg with a colonial-style business district and homes made of wood.

If you ever wanted to know what life was like in early Petersburg, this book is truly a window into Petersburg's past. It tells the story of its inhabitants from the wealthy to slaves. It does not pull any punches or sugarcoat any portion of what it was truly like to live in the city in 1815. Although this book is about a fire that destroyed two-thirds of the Cockade City, it gives you an insight into what was lost. Few people realize how important Petersburg was to Virginia and the country.

While reading this book, I felt as though I was walking the streets of old Petersburg. I came to know the people who lived there. I learned their occupations, their lifestyles and their hardships and enjoyed life with them as they indulged in the entertainment that Petersburg offered. I also came to know the dangers they encountered, from horse thieves to murderers.

This book talks openly about what it was like to be African American living in old Petersburg, both slave and free black. From the slave markets to the largest and first free black community in the country, the story of Pocahontas Island is told in depth. This is a fascinating story of how former slaves came together to form their own thriving community with homes and businesses.

FOREWORD

All of this leads up to the fire of 1815, which is described in great detail. The story of the fire cannot be told without understanding what was lost and how the city rebuilt. I encourage you to step through this window into the past and explore the richness and tragedy of what was and is Petersburg, Virginia.

HENRY KIDD
regional historian and historical artist
August 2015

ACKNOWLEDGEMENTS

There are quite a number of people I would like to thank for their kind assistance as I researched and wrote this book. Thank you to Jeff Seymour, a very talented local photographer in Petersburg, for the countless photos he took of the city for me.

Thank you, also, to Mr. Henry Kidd, a nationally recognized historical artist, for his advice and for writing the foreword to this book.

Thank you to Mr. Dulaney Ward, a local historian and author, for his assistance in locating several historical articles, and to Mr. Richard Stewart, the curator of the slave museum on Pocahontas Island. Mr. Stewart is a treasure-trove of information about Pocahontas Island and the early slave trade in Petersburg.

Thank you to the staff of the Petersburg Public Library, the Library of Virginia, the National Archives and Blandford Cemetery.

Thank you, also, to Mrs. Donna Easter Bowling for her assistance in locating several historic documents. Thanks also go out to Kimberly Ann Calos and Michael Fuller of the Petersburg Pickers for their advice and assistance on furnishings and household items in the eighteenth and nineteenth centuries.

Finally, thank you to my friend across the pond, Mr. Tony Rotherham of Nottingham, England, for helping to proofread some of the chapters and his advice as a professional historian.

Thank you to my family and friends and my coworkers at Fort Lee, Virginia, for their patience with me as I worked on this book.

ACKNOWLEDGEMENTS

Finally, thank you to the citizens of Petersburg, Virginia, who work hard to make this city one of the most interesting and diverse in America.

INTRODUCTION

By the mid-eighteenth century, life for the citizens of Petersburg, Virginia, had achieved a standard not equaled in many other American cities. The citizens of Petersburg were hardy, self-supporting people. The standard of living for the average Petersburg citizen was the highest possible. Men and women who ran businesses in the city enjoyed more disposable income than ever before, and so many products and services were available in Petersburg that few had to rely on obtaining products from other colonies or from England.

The homes of Petersburg were built chiefly of timber, painted with white lead and oil and covered with cedar shingles. The type of home a person or family lived in in the early nineteenth century depended solely on their economic class, from a humble two-room cottage to the extravagant manor homes of the most elite Petersburg families. These homes had detached kitchens and outhouses, as no homes had plumbing or running water in those days. Candles and oil lanterns supplied light, and fires were lit in each room—especially in the winter months—and tended to by servants or slaves.

The large manor homes of the wealthy gentry were very impressive—two and sometimes three stories high, many made of wood, huge fireplaces in each room, a great hall, grand stairways with mahogany banisters carved with fruit and flower designs and hardwood floors. Each home had a stable or carriage house out back; some had barns or sheds for storing tools or tobacco. Wood was a cheap, easily accessible building material, which had a lot of bearing on why so many homes, businesses and warehouses were

INTRODUCTION

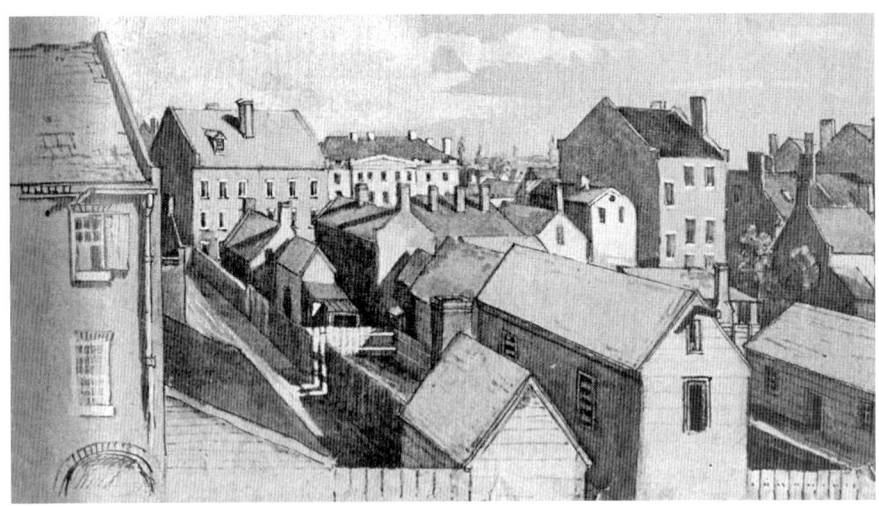

Petersburg, Virginia, in the late eighteenth century. *Courtesy of the Library of Virginia.*

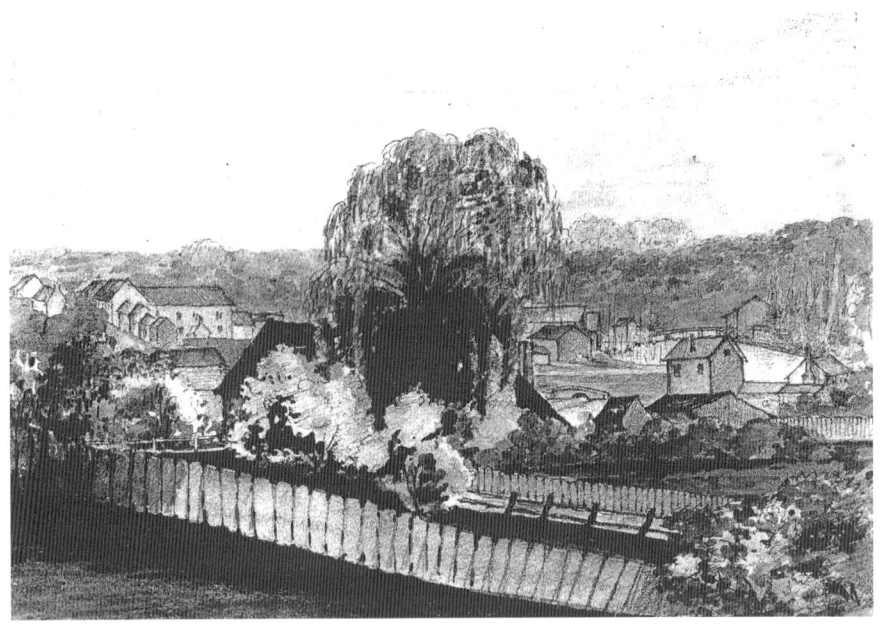

Illustration of late eighteenth-century Petersburg, 1795. *Courtesy of the Library of Virginia.*

constructed of wood in this era. One only needs to look at the style of homes in Colonial Williamsburg today to get an idea of what the homes in Petersburg looked like in the late eighteenth and early nineteenth centuries.

INTRODUCTION

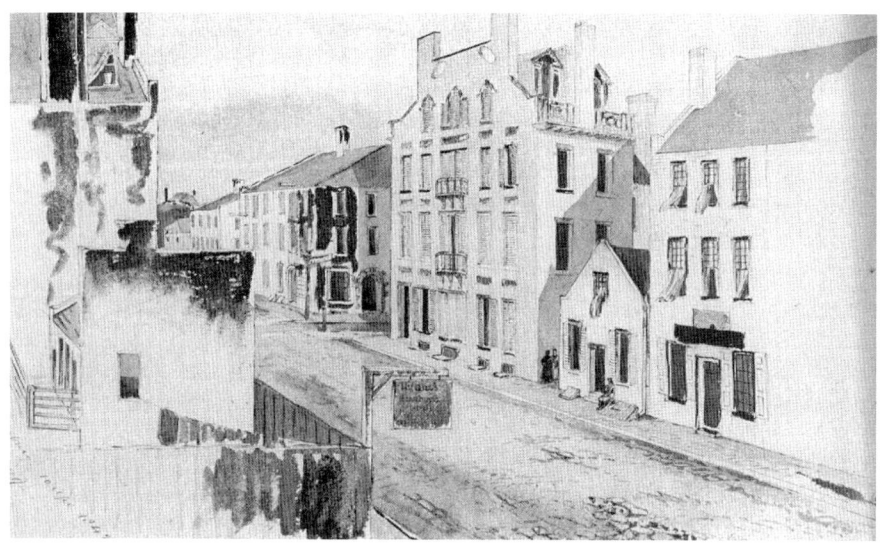

Back Street, late eighteenth century. *Courtesy of the Library of Virginia.*

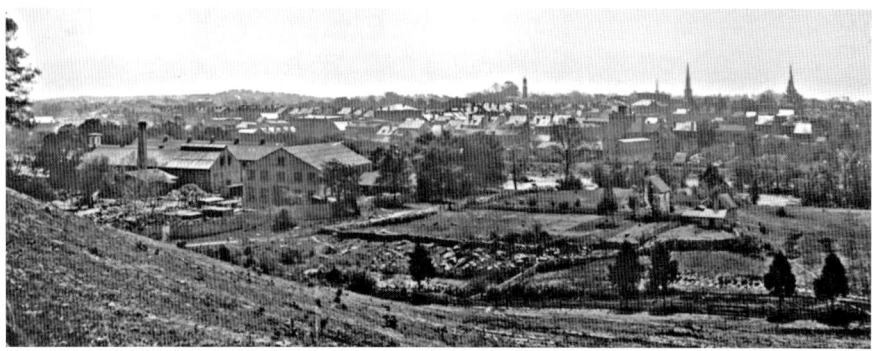

Image of old Petersburg. *Courtesy of the Library of Virginia.*

Even the schools of the time were erected of wood, each with at least one fireplace and the teacher's private apartment above the schoolroom.

The typical family in Petersburg in the late eighteenth and early nineteenth centuries enjoyed a very diverse diet of grains, vegetables and fruits and large quantities of meat. Nearby farms in Chesterfield County, Dinwiddie County, Hopewell and Prince George raised livestock cattle and hogs, obtained milk from dairy cows, kept sheep for wool and grew a wide assortment of fruits and vegetables that were sold at market each week. Local planters grew tobacco, cotton, corn, wheat and barley and kept orchards for growing many fruits.

INTRODUCTION

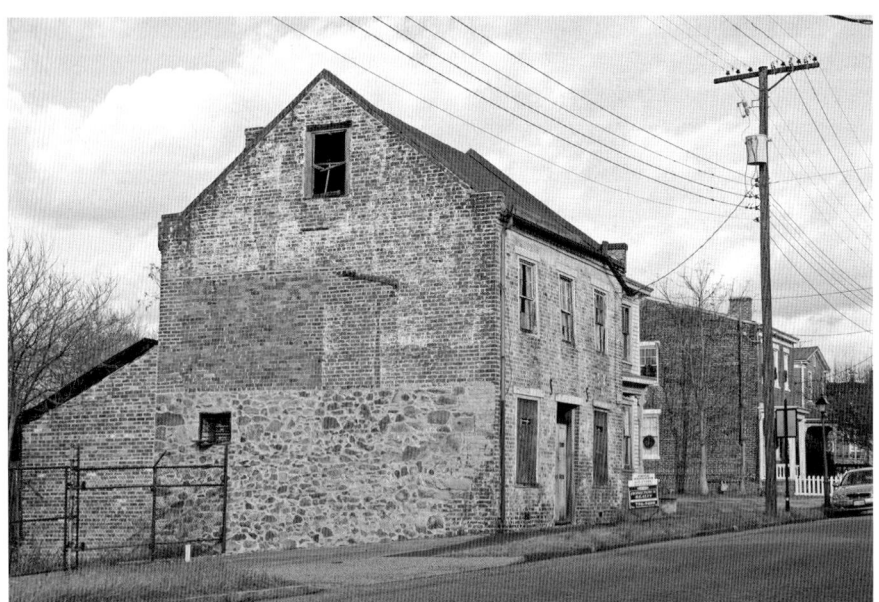

Eighteenth-century home on High Street, Petersburg. *Courtesy of Jeff Seymour.*

By 1815, Petersburg had well over forty grocers operating in the city. Nearly every street had a grocer on the corner who sold pickled and bottled vegetables, molasses, bacon, smoked meats, vinegar, salt, cheese, fresh fruit, butter, eggs, spices, candy, coffee, tea, chocolate and various dry goods. Confectioners sold pies, cakes, candies and special treats. Several bakeries in the city offered freshly baked breads, cakes and assorted goods. On the very end of High Street stood a milk bottling plant. Very early each morning, a wagon arrived that delivered large porcelain jugs filled with fresh milk that was processed in the plant and poured into specially marked bottles with a particular stamp on the bottle that identified the bottling plant. By late morning, freshly bottled quarts of milk were delivered in a wagon to customers all around the city.

The cooking of meals in this era was a major undertaking. In lower-income homes, the housewife and her daughters were chiefly responsible for this task. In the manor homes, slaves produced the family meals in the detached kitchens behind the homes. Huge fireplaces with cooking pots hanging on hooks were the main focus of activity in each kitchen. The slave cook started the fire before dawn each morning, and no sooner was one meal finished than she was busy preparing another.

Not surprisingly, fire was a very real threat to the citizens of Petersburg in the eighteenth and early nineteenth centuries. With the citizens relying on

INTRODUCTION

fires to cook their meals, candles and lanterns to light their homes and roaring fires to keep them warm, accidents and fires were a common occurrence. Toddlers sometimes fell into large cooking fireplaces; candles and lanterns were tipped over in barns and warehouses; some women's skirts caught fire if they stood too close to the fire while cooking. Some criminals resorted to setting fires in order to create diversions and help them escape; for instance, in 1768, some robbers broke into the post office in Williamsburg, Virginia, and set a fire before running out.

In 1788, the Virginia legislature passed an act "to authorize the establishment of fire companies," enabling cities to form firefighting groups, purchase equipment and work toward fire prevention in the community. In Petersburg, the Old Street Fire Brigade, organized in the late eighteenth century, had volunteers, a horse-drawn carriage, buckets of water and ladders. They responded to local fires and put out fires with a long line of men handing off buckets of water and the man at the front of the line tossing the water onto the fire. Not surprisingly, many homes and buildings perished as these men fought to put out the fires.

Firefighting equipment in the eighteenth and early nineteenth centuries consisted chiefly of buckets of water and manpower. Though Mr. Richard Newsham obtained patents to design a "new water engine for quenching and extinghishing [sic] fires" that was capable of pumping two hundred gallons of water per minute, very few cities throughout America actually had one of these engines, as they were expensive at the time. The city of Richmond, Virginia, had a Newsham fire engine around 1803, but Petersburg did not. Instead, most home and business owners were responsible for putting out their own fires, and neighbors often stepped in to help when they could.

Many Americans are familiar with some of the most historical fires that have occurred over the centuries, some of which include the 1731 fire that consumed most of Charleston, South Carolina; four massive fires that destroyed Jamestown, with the final one causing the capitol to be moved to Williamsburg in 1699; the Triangle Shirtwaist Factory fire of 1911 that killed nearly 150 immigrant women and children; and the Hartford, Connecticut circus tent fire that killed nearly 170 circus performers and patrons. Each one of these fires led to far more stringent laws and safety precautions being implemented in an attempt to prevent such tragedies from occurring again.

The fire of Petersburg, Virginia, in July 1815 was so devastating that it remains one of the worst disasters to ever hit the city. And like the other historical fires, new safety precautions were implemented after the 1815 fire in order to try to prevent such a tragic fire from ever happening again.

1
WELCOME TO PETERSBURG!

Welcome to Petersburg! A visitor to Petersburg, Virginia, in the spring of 1815 would have found a city that was already richly steeped in history. Petersburg can trace its history back to 1612, when Captain John Smith listed it on a map of Virginia, naming it "Appomatuck." But the area was already thousands of years old when Smith visited. Native Americans lived in this region well over one thousand years ago. When the English arrived in 1607, the region was occupied by the Powhatan Confederacy, an Algonquian-speaking tribe on the western edge of what is now Petersburg. They were governed by Chief Wahunsunacawh, also known as Chief Powhatan, most famous for being the father of the Indian princess Pocahontas.

The city of Petersburg encompassed land that was taken from three adjoining counties in order to form it: Prince George, Chesterfield and Dinwiddie.

In 1645, Fort Henry was erected at the falls of the Appomattox to protect the headwaters of the river from the Native Americans. Peter Jones later ran a trading post near the Appomattox and named the site "Peter's Point." Colonel William Byrd changed the name to Petersburg in 1733 while laying out the permanent community on property that he owned in order to honor Peter Jones, his companion on a number of backwoods expeditions. He offered lots of land for sale with the stipulation that homes would be erected on the lots within three years of purchase.

The Appomattox River was an essential trade route for flour- and gristmills, as well. These were extremely profitable due to their proximity to

THE GREAT FIRE OF PETERSBURG, VIRGINIA

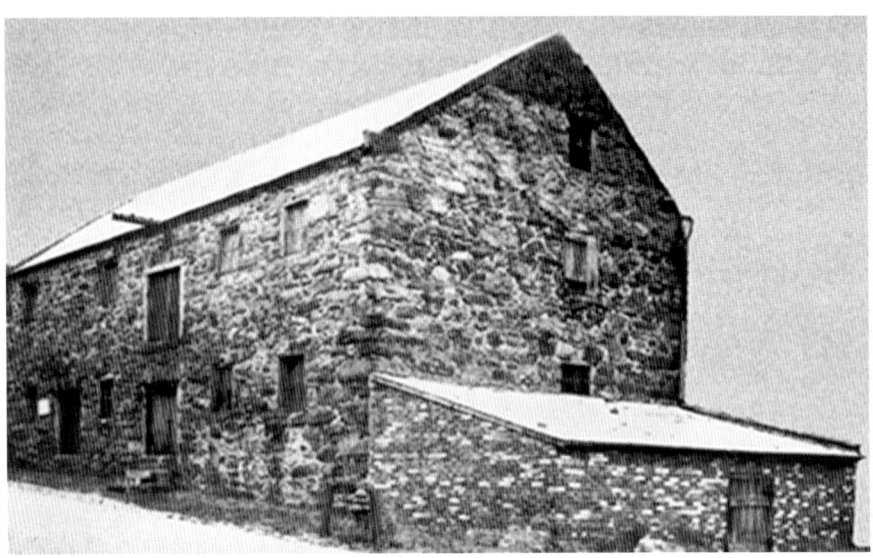

Peter Jones' Trading Post, built in the late seventeenth century. *Courtesy of historicpetersburg.org.*

Richmond and the surrounding counties. The Petersburg millers processed and exported grain and operated large flour mills in the city.

The Upper Appomattox Company formed in 1795 in order to build a canal. By 1807, the Appomattox Canal was a seven-mile conduit around the river falls and cost over $60,000 to construct. The canal provided a navigation system for hundreds of miles from Petersburg to surrounding cities and counties.

In 1781, 2,000 British troops, under the direction of General Phillips, attempted to regain control of the area, and the Battle of Petersburg erupted on April 25 just east of Petersburg. The American troops were retreating across the Appomattox River, ripping up the planks of the bridge in order to attempt to delay the British. General Washington dispatched 1,200 men under the direction of the French Marquis de Lafayette to meet these English forces. They were joined by 3,000 state militia under the direction of General Nelson who attacked the British at Petersburg. Phillips stayed holed up in Petersburg with a fever while the battle ensued, and he later died from the fever. As he lay dying, cannon fire could be heard out his window. He exclaimed, "My God, it is so cruel...they will not allow me to die in peace."

Benedict Arnold took command after Phillips died and sent an officer with a flag and letter to give to Lafayette; however, Lafayette returned the unread letter and refused to have any dealings with Arnold. Cornwallis

WELCOME TO PETERSBURG!

arrived in Petersburg shortly afterward, saving Arnold from being captured by the Americans. He handed Arnold a leave of absence, and Arnold left Virginia to return to New York.

The British managed to drive the Americans out of Petersburg, but they never regained a strategic advantage. Shortly after the Battle of Petersburg, Cornwallis surrendered at Yorktown.

During the War of 1812, the citizens of Petersburg became extremely devoted to the cause. This led to the formation of the Petersburg Volunteers. President James Madison was so impressed with the valor of this regiment at the Siege of Fort Meigs on May 5, 1813, that he nicknamed Petersburg "The Cockade City of the Union" in honor of a feathered plume that the troops wore on their hats, known as a cockade. This nickname was still in effect in 1815.

Communities

In the mid-eighteenth century, Petersburg had already become renowned as a booming commercial city that processed tobacco and cotton grown in the nearby counties and was a major shipping port in the country. Businesses flourished, and new business was constantly being attracted to this thriving city. Cotton and flour mills operated around the city, and several tobacco warehouses and manufacturing plants brought a large amount of money into Petersburg.

By the year 1784, Petersburg comprised seven communities: Pocahontas Island, Old Towne, New Towne, Old Blandford, New Blandford, Ravenscroft and Centre Hill. Each of these communities had its own mill, river docks and a thriving business community.

The Old Town district was composed of the earliest settlement areas of Petersburg laid out in three half-acre lots along the Appomattox River. The main street that ran through it was Bollingbrook, named for the powerful Bolling family, and the area centered on River Street, which was later renamed Grove Avenue. The district had a collection of beautiful, stately homes that were the residences of the most prominent citizens of Petersburg. High Street, in the Old Town district, was one of the most important streets because tobacco and wheat made their way across the levee at the head of High Street on the way to other markets. This area bustled with activity as craftsmen, cabinetmakers, painters, wheelwrights

and furniture makers plied their trades. Most of the workers in these factories and businesses lived in one-story frame workers' cottages on Cross, Canal, Plum and Hurt Streets. A few of these eighteenth-century cottages are still standing today.

By 1762, the town expanded up High Street into what was called the "New Town," which overlooked the Old Town. The street was laid out in twenty-eight one-acre lots, and magnificent homes were built all along the street. The Young Ladies Boarding House was built in 1763 and housed young single women who came to work in the city.

The Ravenscroft community was incorporated in 1784, bordered by Market Street, Halifax Street and South Avenue. The community became a major marketplace for farmers who traveled from various other counties and states to do business in Petersburg. Halifax Street became the major transportation route in the eighteenth and early nineteenth centuries, linking Petersburg to North Carolina.

The Centre Hill district was named for its geographic positioning between two nearby hills—West Hill and East Hill. The Bolling family had acquired the land for this area in the early eighteenth century, and by the time the American Revolution ended, their property extended through the Blandford district, up Sycamore Street, over to Lieutenants Run and into Centre Hill. In 1784, Robert Bolling opened a section of land that he had named Bollingbrook for development. The lots extended from First Street over to Madison Street, into East Bank Street.

The Bolling family lived in a magnificent home on West Hill, and a tobacco warehouse owned by the Bollings was located at the end of West Hill. The borough's courthouse square and complex were located on West Hill, which included the city's jail and a prison. A church and other public buildings also dotted the area.

The Bollings also owned a mansion on East Hill named Bollingbrook, which the Petersburg Volunteers used as a departure point during the War of 1812.

One of the most important districts in Petersburg was the Blandford community. A large number of import and export businesses operated in Blandford and traded with many European markets. One of the largest enterprises in Blandford was the nail factory, one of the first in America, operated by Mr. Roderick Haffey.

St. Paul's Episcopal Church was erected on Well's Hill in Blandford in 1735, replacing an older church that had been built there in 1700. The church was constructed entirely of brick. The graveyard beside the church

WELCOME TO PETERSBURG!

Home of Mrs. Mary Bolling, widow, 1781. *Courtesy of the Library of Virginia.*

dates to 1702. The minister of St. Paul's in 1815 was George Robertson. Vestrymen were listed as Robert Murford, Peter Jones, Arthur Hall, Lewis Green, William McKenna, Henry Randolph, Thomas Bott and Robert Bolling. In 1806, St. Paul's Church moved to Old Town and was erected next to the courthouse.

Some of the wealthiest families in Virginia, made rich through the cultivation and sale of tobacco, lived in vast, lavish homes on streets that featured ancient walnut, sycamore and oak trees. Most of the homes throughout these residential districts were timber-framed mansions fashioned in the styles of those in England, as well as French Colonial, Federal and Georgian. Most of the homes featured colossal stone chimneys in each room and decorative crowns over the front doors, and some featured stately columns alongside the front doors.

Most of the elite homes in Petersburg had domestic slaves who tended to the homes, cared for the gardens, drove the carriages and were personal servants to the master and his family. One of the most important slaves in each home was the cook.

Most of the homes' kitchens were separate from the house, not only because of the fear of fire but also because the odors from the kitchen could become very offensive if they drifted into the house, especially in hot weather. The main cook often lived in a small room above the kitchen and arose

before sunrise to light the fire each day. The cook had a few other slaves, usually all female, to help in the kitchen who washed dishes, carried meals into the house for the family, ground corn or fetched firewood. Some of the homes had basement kitchens complete with bread ovens, but most were away from the main house. Most of the well-to-do families in Petersburg also desired to keep their kitchen servants separate from the main house.

Tobacco—The Chief Product

By 1815, Petersburg, with a population of around four thousand, had been enjoying a long period of prosperity and growth. Tobacco cultivation had become the most essential and lucrative unit of production in Virginia. Several outlying plantations in the area grew tobacco that was brought to Petersburg for processing and storage. These included Brandon Plantation in Prince George; Beechwood, also in Prince George; Kippax in Hopewell; Old Poplar Grove in Chesterfield; and Roseberry Plantation in Dinwiddie County, as well as several in North Carolina. Many of these plantations also rented slaves who were sent to the business district of Petersburg to help in the manufacture of the tobacco. Ads ran in the *Intelligencer*—Petersburg's local newspaper—on a regular basis for the hire of slaves to work as tobacco twisters in the processing plants.

Hundreds of men, women and children toiled in the Petersburg tobacco factories, where thousands of pounds of tobacco was processed each year. As many as nineteen tobacco warehouses—many built in the mid-eighteenth century—were operating in Petersburg by 1815. There were four tobacco auction houses, including Moore's Auction House on North Market Street; West Hill Warehouse on East Tabb Street, owned by the Bolling family; and Oak's Tobacco Warehouse on Third Street, also run by the Bollings. Robert and David Dunlop were two of the wealthiest and most respected tobacconists in Petersburg, owning several tobacco warehouses.

When the tobacco leaf arrived in Petersburg by boat, huge hogsheads of tobacco were rolled off the boats and over to various warehouses, where they were broken open by the workers, the weed was inspected for quality and weighed and then the tobacco was stored until auction day, when many foreign and local merchants came to purchase it. Some local merchants purchased it to fashion into cigars and pipe tobacco that they sold in their shops in town.

WELCOME TO PETERSBURG!

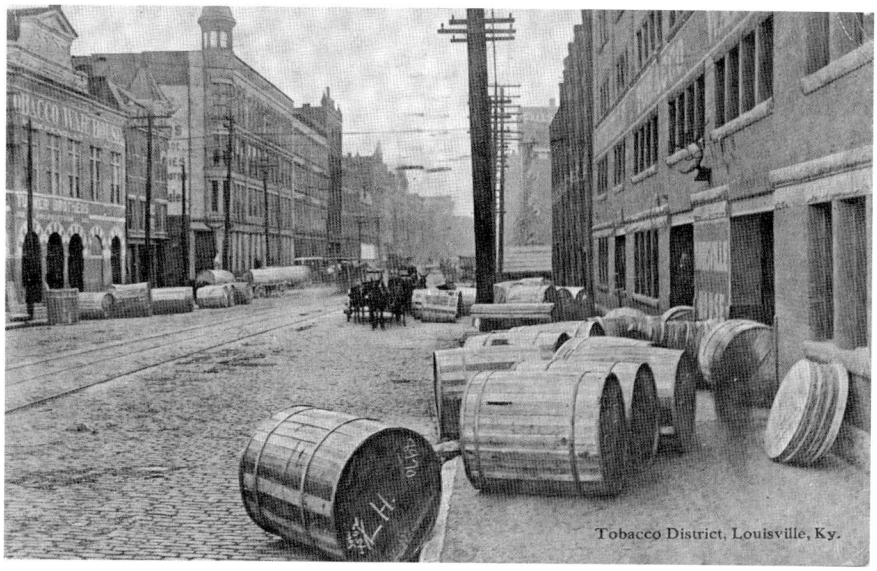

Tobacco hogsheads. *Courtesy of the Kentucky Digital Libraries.*

SLAVES

On a regular basis, boats came up the Appomattox River carrying tobacco, grain, cotton, various supplies—and a large number of slaves. Slavery was the second most prosperous business in Petersburg. In fact, some of the most respected citizens in Petersburg were slave traders. Two of the most lucrative slave trading businesses were operated by Richeson and Son and Mr. G.K. Taylor, who operated on Old Street, where they sold "valuable slaves" at auction. Slave traders made vast amounts of money buying and selling slaves on the market. A slave trader could stand to make what would be worth over $600,000 in contemporary monetary value in one year selling slaves. The slave auction house stood on the corner of what is now Sycamore and Bank Streets, and planters and businessmen came from the surrounding counties on auction days to buy and sell slaves. A holding cell stood behind the market house where slaves were kept until the auction. Some local businessmen also came to rent slaves from local planters to work in the tobacco factories and warehouses.

Petersburg was Virginia's third largest city by 1815, and nearly half of the four thousand residents were slaves. Slaves arriving in Petersburg usually came from slave pens at Bermuda Hundred or Osborne's Landing in

THE GREAT FIRE OF PETERSBURG, VIRGINIA

Chesterfield County and from Shockoe Bottom in Richmond. Petersburg was one of the leading slave trading cities in Virginia, following closely behind Richmond and Alexandria.

Slaves brought into Virginia on the James River arrived in Richmond, where they were placed in slave pens until they could be transported down the river into Petersburg. They arrived in Petersburg on the Low River Trail and were unloaded on Canal Street and taken to the slave pens on Rock Street. At least once per week a slave auction took place on the corner of Sycamore and Bank Streets. This particular slave market had stood in that spot since the early 1700s. Planters from the surrounding counties came into Petersburg to buy and sell slaves, and many local businessmen and women rented slaves at this site to work under contracts in their factories and businesses throughout the city. Many of the boats bringing slaves into Petersburg also brought cotton, grains, tobacco and vegetables and fruit grown on the local plantations to be sold or processed in the mills and factories in the city.

In Petersburg, the main market square was located on River Street at the intersection of East Old Street. Every week as slave auctions took place, they drew a huge crowd in the market square. The price of slaves was always a constant topic of conversation among the merchants of Petersburg and planters from surrounding counties, and advertisements ran on a regular basis in the *Petersburg Intelligencer* about upcoming slave auctions alongside notices about runaway slaves. Most slaves being auctioned off in Petersburg came to the city because their master on a neighboring plantation had died. Slaves were usually sold in this case to satisfy any debts left by the deceased. Professional slave dealers in Petersburg were in charge of securing the slaves, running the advertisements in the newspaper and posting auction notices outside the auction house.

One unfortunate result of the slave auctions was the separation of slaves from their families. Husbands and wives were sold away from one another, and women screamed as their babies and young children were ripped from their arms. Yet the prospective buyers were oblivious to the heart-wrenching scenes as they went about their business of examining slaves, placing bids and carting away newly purchased slaves in shackles and chains. Many of these auctions included a large number of young children. In April 1815, a large slave auction took place in Petersburg's market square. Ten slaves were sold to local Petersburg tobacco merchant Peyton Mason, and seven of the slaves were children under the age of twelve.

WELCOME TO PETERSBURG!

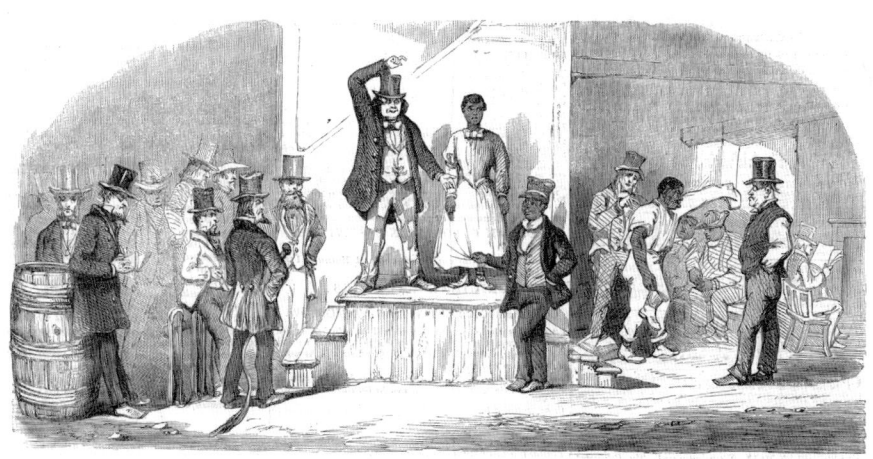

Illustration of slave auction. *Courtesy of Wikimedia Commons.*

There was also a large exportation of slaves from Petersburg on a regular basis. Slaves were usually sold to plantations down south in the cotton belt. In fact, the great demand for slave labor on Deep South plantations caused the price of slaves to skyrocket—which allowed the slave merchants of Petersburg to amass fortunes as they were able to demand very high prices for slaves.

The merchants and citizens of Petersburg relied on slavery as much as the local planters and were able to acquire more wealth and status as a result of slavery, as well. In fact, slavery was seen as a necessary means of increasing profits as well as gaining more upward mobility in the community. Many settlers were attracted to Petersburg from Europe and several northern colonies, including many skilled artisans. Those who could afford to purchase a few slaves soon found themselves increasing their profits and moving up the societal ladder. Not only did some Petersburg merchants and artisans put slaves to work in their businesses, but they also kept them in their private homes. Slave women worked as maids, cooks, nannies and seamstresses, while slave men were carriage and coach drivers, blacksmiths and saddlers, as well as household servants, including butlers and footmen. The largest numbers of slaves were owned, exclusively, by the Eppes, Jones, Randolph, Boisseau, Friend, Hinton, Dunlop, Ruffin, Stewart, Bolling and Bott families in Petersburg. In fact, there were literally around one thousand slaves among these men, in their private homes, on their numerous plantations and working in their warehouses and factories throughout the city—far too numerous to name all of them. Painstaking research has also uncovered a

slave database from Petersburg, Virginia, in the year 1815, which is included in the appendix of this book.

With nearly half the population of Petersburg being slaves, there always arose the problem of trying to keep all of them in line. There were numerous other careers that only flourished during the institution of slavery, including bounty hunters, who were employed to chase after escaped slaves, and overseers, who supervised slaves in the fields and meted out punishments, including whippings and brandings for slaves who were thought to not be working hard enough or who either escaped or attempted to escape.

A planter from Dinwiddie, Mr. Eli Brown, wrote in his journal about visiting the market in Petersburg in 1800 and witnessing a young slave woman tied to the whipping post in the town square: "She was stripped completely nude, her arms were tied above her head, and she was being punished with a heavy raw-hide whip." What stood out the most for him was how most of the crowd seemed oblivious to the scene unfolding before them. He stated there seemed to be a particular sense of cruelty on the part of the man carrying out the whipping, as he "spit tobacco juice on the ground every few minutes, and smiled and laughed several times."

The wealth generated on the outlying plantations by slaves also benefitted many of the artisans in Petersburg who didn't own slaves themselves, but many of the merchants realized that in order to increase their social awareness in the community, they needed to own at least one slave because this became a visible symbol of their success—especially if they could have slaves help in their business and run their private homes, as well.

Though the institution of slavery was abominable in every way, there were instances of some slave owners who became very close to their slaves and treated them like members of the family. One such example is that of Lucy Lockett, who was born on a Chesterfield plantation on July 15, 1771, and became a domestic slave in the manor home. She was sold to the Green family as a young girl and lived out the remainder of her life as a slave to them. She died at age sixty-four on January 29, 1836, and was interred in Blandford Cemetery in the Green family plot—something not normally done at the time. Her tomb inscription reads: "In memory of Lucy Lockett, a slave yet not less the friend of her Master's family, by whom is offered their testimonial of their esteem for her excellent virtues, and true piety, for her affectionate and faithful services and grief for her death. Born July 15, 1771 died Jan. 29, 1836." Most slaves were buried in a specified area on the plantation back then, separate from the family burial plots. But it becomes apparent the devotion the Lockett family felt for their slave Lucy.

WELCOME TO PETERSBURG!

There also existed a large free black community in Petersburg on Pocahontas Island. The island dates back to 1732, when some of John Bolling's tobacco warehouses were located there. Initially it was named Wittontown and then was renamed Pocahontas Island in 1752, becoming the first free black residential community in America. In 1797, Sandy Beach Church was erected on the island. It later became Gillfield Baptist Church, which still stands on Perry Street today. The citizens of Pocahontas Island built a thriving business community, but some of the free blacks owned and operated some businesses in the main city, as well. William Colson and Joseph Jenkins Roberts operated a barbershop on Sycamore Street. Free black man Henry Elebeck co-owned another barbershop on Bollingbrook Street with Colson. Henry Elebeck, son of a prominent free black man, owned several houses in Petersburg and lots valued at over $1,000. He came to Petersburg from Pennsylvania in 1802. In December 1810, the residents of Petersburg, including the mayor, petitioned the general assembly to allow Elebeck to remain in Petersburg despite a 1793 law that forbade free blacks from coming from other states to settle in Virginia.

First Free Black Community in the United States

In 1726, Colonel John Bolling, the great-grandson of Pocahontas and John Rolfe, purchased the peninsula that became known as Pocahontas Island, which he named in honor of his grandmother. African slaves were brought onto the island to help build the tobacco warehouse, and free blacks from Petersburg went to work in the warehouse as tobacco sorters, packers and laborers. They packed tobacco in large barrels that was then transported to various foreign and domestic markets. The free blacks built homes near the tobacco warehouse on Pocahontas Island and created the first free black community in America. By 1815, Pocahontas Island was the largest free black community in the country.

Located across the Appomattox River from Petersburg, Pocahontas Island was not originally designated as an island. Chesterfield County lay across one side of the island, Petersburg across the other.

It remains unclear when the first African Americans arrived in Petersburg, but evidence of their presence in the city dates back as far as the 1600s. Some arrived as indentured servants and, upon completing their term of indenture, were granted their freedom.

THE GREAT FIRE OF PETERSBURG, VIRGINIA

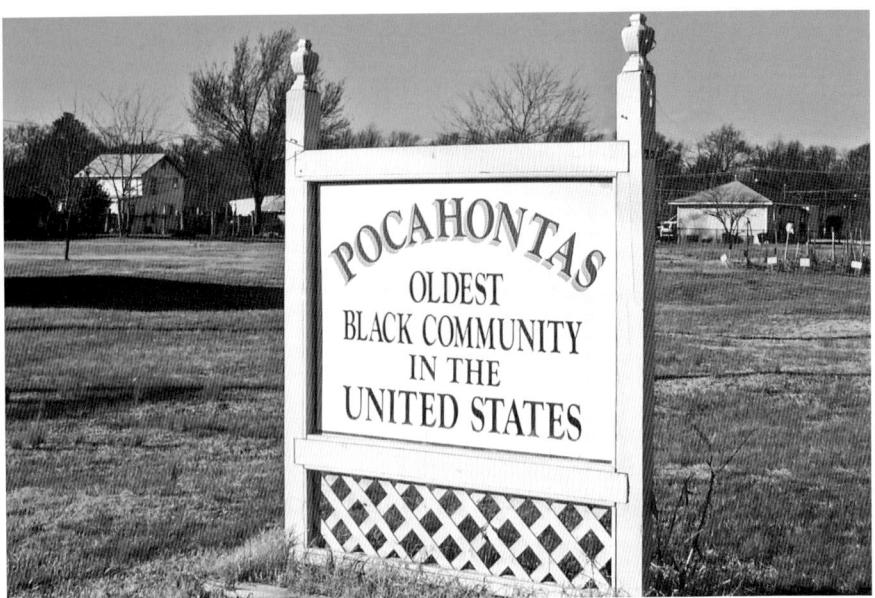

Pocahontas Island marker. *Courtesy of Wikimedia Commons.*

Between 1782 and 1810, a large influx of mulattoes arrived on Pocahontas Island. The vast majority of these people were the offspring of a white master and an enslaved African woman. After the Revolutionary War, several planters chose to free their natural-born offspring, and they found their way to the island.

Some of the inhabitants of the island came along after their master died and were granted their freedom in the master's will. Mr. John Gilbert Peniston owned a large home on Bollingbrook Street that was built in 1811. He owned a large number of slaves but is known to have freed at least two of them, including a child named Kinchen, whom he not only freed in 1800 but also gave $1,000 to in his will. Some slaves were able to buy their freedom, also. The remaining free blacks were born free to free black mothers.

The free blacks of Pocahontas Island turned the community into an integral commercial development by the early nineteenth century. The community soon consisted of boat builders and riverboat operators, as well as various skilled tradesmen of every sort. Mr. Joseph Jenkins Roberts operated flatboats on the Appomattox and James Rivers and a trading company with Mr. William Colson.

By 1815, at least a third of all African Americans in Petersburg were free persons, many of whom owned property. During the American Revolution,

WELCOME TO PETERSBURG!

many African American men earned their freedom by serving in the war. The 1790 census indicated that 310 free blacks lived on Pocahontas Island.

The early nineteenth century was still a difficult time for African Americans—even those with free status. So many laws and ordinances had been passed that restricted nearly aspect of their lives. Free black persons could not sit on a jury, could not vote and faced many obstacles in the community that they worked and lived in. The free blacks were required to register, another way of controlling their movements. Many of the free blacks of Pocahontas Island ran their own businesses and owned homes and property. And in spite of incredible odds stacked against them, most of them succeeded in their businesses. They operated inspection stations, tobacco warehouses, lumberyards, mills and private businesses. These businesses became vital to the city's commercial center. Some blacks, however, went into the city to work each day as laborers, tobacco warehouse workers, restaurant porters and domestic servants. But this was a risky venture, for many free blacks were deemed, by whites, as "slaves without an owner," and they were treated accordingly.

African Americans were a vital part of Petersburg and contributed greatly to the building of the city's infrastructure, erected the early buildings and built roads and bridges.

A bridge connecting Pocahontas Island with Petersburg was erected in 1752, further allowing more commerce and trade between the two communities. The island was incorporated as part of Petersburg in 1784.

Mr. Richard Jarratt was the leader of the Pocahontas Island community and helped found the Sandy Beach Church in the early 1800s. He lived in a large home on Logan Street on the island and engaged in the fishing and carrying trade at the time of the Great Fire. He carried goods from Petersburg to Norfolk each week along the waterways. His son, Alexander, worked alongside him and later inherited the business from his father.

In 1800, the free black population on Pocahontas Island exploded due in part to the influx of Haitian immigrants. By 1803, the white citizens of Petersburg, who had considered the Haitian immigrants "dangerous," forbade all free blacks from carrying firearms.

In 1815, shortly before the fire that destroyed three-quarters of the city, Virginia began granting free blacks permanent resident status in the state.

As early as the late 1700s, many escaped slaves were being given refuge in homes on Pocahontas Island. By 1810, a home that stood on Witten Street on Pocahontas Island had become one of the major hideouts for escaped slaves in the region. At least two other homes on the island were

also known to be hideouts. Nearly all of the inhabitants of Pocahontas Island were involved in helping hide the escaped slaves, which made it even more difficult for bounty hunters who were tracking them.

The Market Square

As early as the mid-1700s, a market square stood near the Appomattox River on what is now Old Street. A charter granted by King George I in 1722 designated every Wednesday and Saturday as market days. Vendors and shoppers alike gathered in the market square to buy and sell tobacco, cotton, wheat, homemade soap, fruits and vegetables, livestock, freshly butchered meat and live and dressed poultry, eggs, butter, milk, corn, fresh fish from the Appomattox and James Rivers and shellfish from the Chesapeake Bay, including oysters and crabs. Women sold their freshly baked breads, cakes and pies, and merchants came to hock their wares and merchandise.

The atmosphere of the market square was lively and animated—fiddlers played on the corners, cockfights and other vices took place behind the alleyways and the local theater groups performed in the town square or put on puppet shows for the children. Slave owners rented out their slaves to the manufacturers in the city and on Corling's Corner, which is now located across the street from the popular restaurant Longstreet's Café on Bank Street. In the market square, slaves were sold at public auction. Free blacks were permitted to sell their own meat, poultry, fish, fruits and vegetables in the market square, as well.

In 1808, the "new" farmers' market building was erected on Old Street. Shoppers were now able to go inside the building to purchase tobacco, cotton and slaves. This building burned in the fire of 1815 and was rebuilt in 1816.

Educating the Young

A public school system had not been developed in Virginia in 1815. Some of the surrounding counties had crudely fashioned one-room school buildings where children from the area could go to learn basic math, writing and reading. These schools were taught by one schoolmaster who instructed

children in all grades. They were approved by their local parish and received their salary from the local citizens and merchants.

The children of Petersburg lived lives defined by their parents' economic standing in the community. While children living on farms in the surrounding counties may have spent several hours per day working alongside their parents in the fields, the majority of families in the central Petersburg area were of higher middle and upper classes. And though they had servants and slaves to help in their homes and care for them, freeing them from manual labor and affording them far more leisure time, children from these classes also bore a great deal of responsibility when it came to their education.

There were three schools in the city of Petersburg in 1815, and Mr. John Burk, Mr. John Newsum and Mr. Jonathan Smith were the schoolmasters. In those days, most teachers were male. A one-room school, built in 1790, stood on Perry Street, which intersects with Washington Street. Mr. Smith lived in the upstairs section of the school, while the downstairs was a schoolhouse for boys up to eighth grade.

Jonathan Smith was born in Abingdon, Virginia, on July 3, 1779, and began teaching in Richmond in 1795. He came to Petersburg in 1810 when

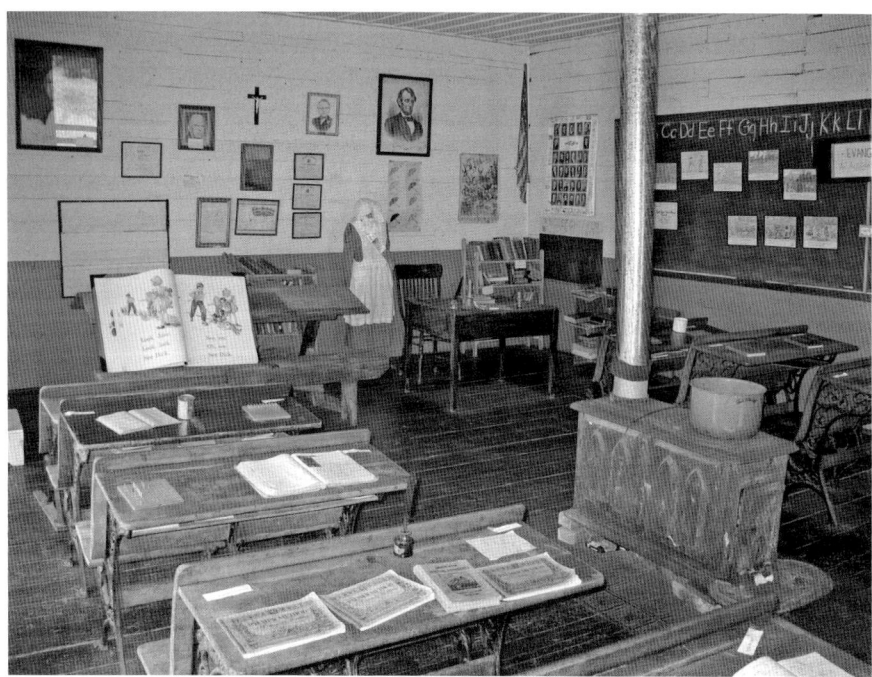

Inside an eighteenth-century schoolhouse. *Courtesy of the National Park Service.*

THE GREAT FIRE OF PETERSBURG, VIRGINIA

he ran an ad in the *Petersburg Intelligencer* advertising the fact that he had just relocated to Petersburg, had taught for fifteen years and was operating a new school on Perry Street where he would teach boys between the ages of five and fourteen "cyphering, reading, writing, classic literature, Greek, and Latin." He reiterated in the advertisement that the parents of the boys were responsible for paying Mr. Smith's salary as well as purchasing books and materials for their sons. The school burned in 1829, and a private home was built on the site in 1830. Mr. Smith became the principal of the Dinwiddie Academy, which had opened in 1812, and then became the headmaster of the Petersburg Female Academy, located on Washington Street, in 1832. Miss Ann Clark was hired to be the headmistress of the academy. Mr. Smith remained there until he retired in 1835 and lived in Petersburg with his wife, Mary, until his death on November 1, 1843. He was laid to rest in Blandford Cemetery.

Schooling for children was not mandatory in Petersburg. But most of the upper middle and upper classes believed a strong education was important for their children. John Newsum ran an ad on December 29, 1807, in the *Petersburg Intelligencer* stating that he had room to accommodate boys ages twelve to fifteen in his school "as boarders," and "he professes to teach the English language grammatically, arithmetic, Latin, &c."

Reverend Andrew Syme was the minister at St. Paul's Episcopal Church. Behind St. Stephen's Episcopal Church, the Reverend Syme operated the Episcopal School for Boys, which opened in 1794. In 1813, it acquired the land on Washington Street where the original Petersburg High School was built, now the Governor's School for the Gifted. The Reverend Minton Thrift, a Methodist minister, operated a school for boys in Petersburg at the same time.

Some girls attended dame schools operated by affluent women in the community. There they learned dancing, French speaking, sewing and needlepoint and proper etiquette. Boys from the upper classes attended the schools in the city of Petersburg, where they learned reading, writing and math in the early grades and classic literature, Greek and Latin in the upper grades. The boys' parents were responsible for purchasing books and paying the schoolmaster. Some boys from lower economic families were apprenticed to the schoolmasters. They were responsible for arriving at the school early each morning to build the fire, wash the boards, prepare classroom materials, sweep the floors and care for school supplies, including books and candles.

Mrs. Jacob Mordecai operated a boarding school for girls where they were taught English grammar, spelling, reading, writing, arithmetic, composition, history, geography, needlework, drawing and vocal and instrumental music.

WELCOME TO PETERSBURG!

For $105 per year, the girls received room, board and tuition, and their clothes were washed by servants. Students were requested to bring along with them "a pair of sheets, a blanket, and hand towels," which "would render them more comfortable." On September 23, 1808, an ad was run in the *Petersburg Intelligencer* for the employment of a schoolmistress at Mrs. Mordecai's school to help educate twenty-five girls for the salary of $1,000 per year. This was considered a very high salary in 1808, indicating the wealth of the parents who sent their daughters to this elite school.

One of the most important aspects of school for the upper-middle and elite classes was to prepare the students for life in a rigid, class-conscious society in which one class of people had power over those beneath them. This class system was quite prevalent in the schools in Petersburg, as elsewhere in Virginia. The schoolmaster held power over all of the students, and the older students held power over the younger children. Unfortunately, bullying and abuse was as much a part of school back then as today.

The schoolmaster had an obligation not only to instruct his pupils but to punish them, as well. In fact, brutal corporal punishment was very much a part of the public education system in early Virginia and was considered good for a child's overall character development. Most of the punishments

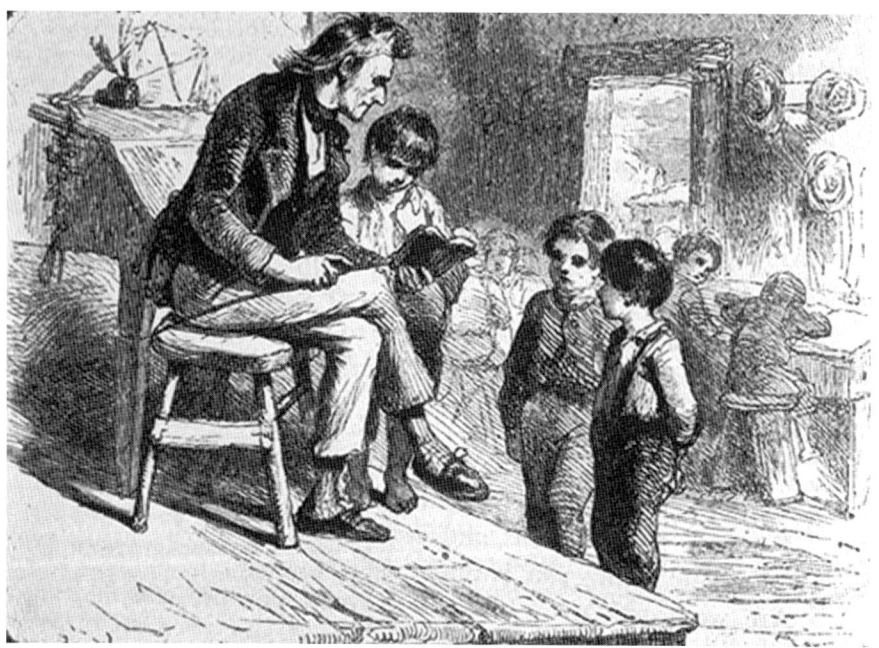

Illustration of a schoolmaster. *Courtesy of PB Works.*

might seem harsh by today's standards. They included the pupils being whipped by the schoolmaster with a birch rod because it was felt that an unruly child should be whipped. However, children who were slow to learn were usually also punished by either whippings or public humiliation, such as being relegated to a corner and forced to wear a dunce cap.

Children in early Virginia were subjected to a great number of rules that governed their behavior, especially in school. Some children were punished for merely humming, laughing, whispering, "wriggling about" or not standing up to speak to the schoolmaster.

Schools operated for white children only. In the early nineteenth century, it was still illegal to educate blacks, regardless of their status as free or enslaved. Laws had been implemented prohibiting the teaching of reading and writing to any black in Virginia, including Petersburg.

Apprentices

In the early nineteenth century, Petersburg was still marked by the division of social classes. For children from lower-income homes, whose parents could not afford to send them to the private schools in the city, most were taught basic skills at home. Boys usually worked on the farms or helped their fathers in their trades, while girls were taught household skills by their mothers. Some women were literate and able to teach their children basic mathematics, reading and writing.

Some children from the lower classes entered into labor contracts with artisans in the city. The master usually agreed to provide room, meals, clothing and other necessities and, in some cases, a small allotment each week, as well as teach the child a valuable trade that they could later earn a living at.

Little boys were usually apprenticed at around age ten. They learned trades such as butchering, blacksmithing, milling, carpentry, wheelwrighting, candle making and barrel making, as well as working in tobacco factories and some of the dry good and mercantile shops. Some became apprentices to the local undertaker, and a few others worked in the graveyards, helping to dig fresh graves for burials. The children were usually bound by a contract between them and their master and were apprenticed for a certain number of years—usually seven to ten. Due to the nature of the labor market, most apprenticeships were awarded to young boys. Little girls were usually

WELCOME TO PETERSBURG!

hired by some upper-class households to work as domestics, and some were afforded a basic education or taught a skill that they could rely on to earn a living, such as delivering babies.

The Business of Birthing

By 1815, Petersburg had around four thousand citizens. As was the case with any town, midwives were a very valuable commodity. Miss Elizabeth Swail and Mrs. Sarah Weatherly were considered two of the most trusted midwives in Petersburg by 1815. Elizabeth Swail lived with her mother, Ann Swail, who ran a grocery in Old Town. The women also rented apartments above the grocery and were two of the most prominent businesswomen in the city. Unfortunately, in spite of the women's skills as midwives, there existed a high infant mortality rate in the early nineteenth century. In fact, Blandford Cemetery has numerous burials of babies from this era, many who were buried before 1815.

Wealth and status certainly provided for a more comfortable lifestyle, but it did not guarantee a healthy pregnancy or delivery. In the eighteenth and early nineteenth centuries, some of the most elite families in Petersburg suffered from the loss of several babies and/or the death of the mother in childbirth. One example is Mrs. Roger Mallory, the wife of the former justice of the peace, who died in childbirth at age twenty-one on April 14, 1815. Attorney Ebenezer Stott, who operated a law office in Petersburg with James Watson, married Elizabeth Phile, daughter of a wealthy Petersburg businessman. They lost five babies, one after the other, and then Mrs. Stott died in childbirth giving birth to her sixth child—all of them are buried together in Blandford Cemetery. The baby, Helen Stott, died at age fifteen months. Even one of the wealthiest families in Petersburg, the Dunlops, could not escape the clutches of death. John Dunlop's wife, Mary Ruffin Dunlop, lost a baby daughter and a son, who only lived eighteen days. They went on to have several other children, but three of them died as young children.

Orphans

Unfortunately, throughout the eighteenth and nineteenth centuries, many children were orphaned in Petersburg. In 1790, Sir Robert Bolling donated

several acres of his land near the Appomattox River for an orphan asylum. Later that year, the Petersburg Poorhouse and Orphan Asylum opened. It housed poor vagrants, unmarried pregnant women and orphaned children and foundlings. Most of the adults living there were required to be indentured to businesses or plantations in the area or to work in the asylum itself.

The manager of the asylum sought legal guardianship over the orphans in order to avoid any outside interference, also allowing the manager to enter the children into apprenticeships in the area. The local court could interfere and remove the child from an apprenticeship if it were learned the child was being abused or neglected. Young unmarried women were employed to care for the babies and children under the watchful eye of a female matron. In 1809, Mrs. Treadway was hired as the matron of the orphanage.

In 1810, the children from the orphanage were entered into a contract with several of the tobacco factories in Petersburg. Most of the children spent their days twisting tobacco and processing the newly arrived hogsheads of tobacco. The managers of the factories agreed to feed the children in exchange for their labor. The goal of the program, according to the orphanage, was to teach the orphans a viable trade that would allow them to be self-sufficient as adults.

In 1812, an orphanage for girls called the Petersburg Female Orphan Asylum opened on Sycamore Street, run by the local Methodist church. Most of the girls from the orphanage were apprenticed to the local households to work as house servants. Citizens and merchants from Petersburg also helped support the orphanages with donations throughout the year. The local theaters also donated some of their annual proceeds to the orphanages.

A Visit to the Business District

In the early summer of 1815, a visitor to the business district of Petersburg would have found a thriving district with over three hundred buildings of nearly every trade and service that anybody would ever want. Petersburg was important not only for its role in the production of tobacco but also the flour and grain mills, which produced over 600,000 barrels of products each year. Trade exports amounted to over $1 million and shipped around five thousand tons of goods each year. Many civic improvements had taken place in prior years, including filling a very large marsh and building a new street called Bank Street that connected High and Back

WELCOME TO PETERSBURG!

High Street, Petersburg, 1805. *Courtesy of the Library of Virginia.*

Streets. Petersburg's principal street, Bollingbrook, was paved in 1813, but no other streets were paved.

The roads leading into Petersburg's business district were primarily made of dirt. On a normal day, this did not cause much trouble, but when it rained or snowed, the streets became very muddy. Carriages and wagons coming into the city on a rainy day often became stuck in the mud, and numerous men came out to help pry the wheels from the mud. Little boys dashed in and out between carriages, nearly being trampled by horses, in their attempt to catch bullfrogs leaping around in the streets. One can imagine what a comedic, chaotic scene this would have created.

A visit to one of these businesses would have found a clerk keeping a ledger in which they wrote the names of their customers, their purchases and the dates they purchased goods, as well as their credits, payments and debts. Beginning on Old Street, one would have found four tenement homes owned by Hector McNeil and several tobacco warehouses; the Golden Ball Tavern; Ann Swail's Grocery; Elizabeth Swail, midwife; and Sarah Weatherly, midwife. Mr. Thomas Wallace owned the *Petersburg Intelligencer*, established in 1785, which stood at the corner of Sycamore and Old Streets. Edward Sparhawk was editor of the *Petersburg Intelligencer*. Mr. John Dickson was in charge of collecting subscriptions to the newspaper, at four dollars per year. Mr. Thomas Warrell operated a dance school, and Edward Powell

THE GREAT FIRE OF PETERSBURG, VIRGINIA

ran a tavern. In 1808, Mr. Augustino Fromento came from Italy and opened a hair salon for ladies on Old Street that drew in a large clientele. He rented a space above Powell's Tavern for this salon. On Sycamore Street, a visitor would have found Mr. Cottom's Book Store, Bragg and Jones' Apothecary and Yancey and Whitworth Printers. On Bank Street were John Gowan's Grocery and Law Offices of Farrar, Boast, and McCay. On Back Street were Dr. William Moore's Boarding House; the Back Street Theatre; John Davis' Distillery; John Hinton's Grocery; the Virginia Inn; the Silversmith; the Westbrook Tobacco Warehouse; Heslop, Colquhoan, and Byrne Lumber House; the Merchants Hall; and the Old Street Theatre. On Bollingbrook Street were Selby and Harned's Dry Goods Store; George and Milliman's Confectionary; Pearce's Saddlery; Bennet and Thomas Watchmakers; Mrs. Phoebe's Millinery; Justus Smith's Apothecary; Wilkinson and Wells Grocers; Colquhoun's Dry Goods; Pollard's Saddlery; Lochhead's and Davis' Dry Goods; Mary Ann Bolling's Tenement House; Law Office of William Cummings; Dancy and Gibbons Mercantile; Sharpe's Grocery; Law Office of William Johnson; Frederick Williams' Grocery; Mr. E.G. Blake, Esq.; Charles Russell's Grocery; Law Office of Mr. Richard Bates; the Columbian Hotel; John Patterson's Grocery; the Shoemaker's Shop; Mrs. Ephram Geddy's Estate Auctions; the office of George Brown, Esq.; Mr. Littlejohn, Shoemaker; Cameron and Townes, Attorneys at Law; Mr. John Hart's Tinnery; Mrs. Adams Boarding House; the Farmer's Bank; Dillworth and Dunnavant, Printers; Mrs. Miles Millinery Shop; J.E. Reviere Confectioner; Williams' Mercantile; William Robertson's Tenement House; John Banks, Tailor; Collins Dry Goods; Colin Alfriend's Grocery; William Cain, Tailor; Nathaniel Friend's Dry Goods; Haxall's Vendue Office; Haxall's Lumber House; Ryan's Dry Goods; J.W. Campbell's Book Store; Heslop Law Office; Neilson and Brewer's Grocery; Potter and Geise's Hardware; Clarke and Gordon's Dry Goods; Mitchell's Mercantile; William Barker's Hat Shop; Pascal Wells, Tailor; John Magie, Apothecary; Solomon High's Grocery; Russell Hill's Dry Goods; the Market Square; the Market House; Allan Mitchell's Grocery; Pace and Cate's Grocery; James Boyle's Grocery; Samuel Turner, Esq.; John Wright, Shoemaker; Follet and Lea's Hardware; Smith's Grocery; Turner and Goodwin Grocers; James Boisseau's Grocery; Pride's Shoes; Canterbury's Grocery; Frazer's Grocery; Mr. Fisher's Hat Shop; Moore and Love's Wholesale and Retail Druggists; Frances Lynch's Hat and Bonnet Shop; Richard Cocke Stagecoach Lines (which ran between

WELCOME TO PETERSBURG!

Golden Ball Tavern, built in the mid-eighteenth century. *Courtesy of Woodhaven Historic Photos, woodhavenhistoric.com.*

Portsmouth and Petersburg three times weekly and carried mail between the cities); and Thomas Neilson's Dry Goods and Distillery. On High Street one would find several more tobacco warehouses, a ladies' clothing and shoe store and a fruit and vegetable stand alongside a bakery and another grocery. There were physicians' offices, some painting and building companies and craftsmen who created such luxury items as silver candlesticks, mahogany beds and expensive furniture. An iron foundry shop and a shoemaker were on the end of High Street, and a coach maker, gunsmith and shipping merchant were located across from them. On the very end of High Street stood a grain mill and a milk bottling plant across from a butcher shop. Along High Street were several taverns that also rented out rooms above them. Mr. Joseph C. Swan operated a book binding business at the end of High Street, and Samuel Stephens ran a shoemaking business next to the book binder.

THE GREAT FIRE OF PETERSBURG, VIRGINIA

Entertainment

The citizens and merchants of Petersburg worked hard, but they also made time for entertainment and relaxation. Every summer, the fair would open in Petersburg, which drew huge crowds. An open-air market sold fresh baked goods, jellies and jams and homemade items for the home. Performers and magicians entertained the crowds, and storytellers captivated children with fables and fairy tales. On September 10, 1808, Mr. Simon's Circus arrived in Petersburg and featured acrobats "performed exhibitions on the tightrope, &c." Admission to the circus was fifty cents, according to the advertisement. Philip Lailson's Circus came to Petersburg several times in the late eighteenth and early nineteenth centuries. Each time it arrived in town, the entire troupe and the circus animals would parade down Sycamore Street. Clowns, jugglers, fire eaters and acrobats performed stunts in the street to advertise the upcoming circus that evening. They were known for putting on one of the grandest displays of showmanship in the city. A circus barker stood outside the circus tent shouting to the crowds to come see a spectacular show.

Children in Petersburg played counting games, jumped rope, rolled a hoop with a stick, spun whirligigs on a string, tossed ribboned hoops to one another using sticks and played games such as hide-and-seek and "shut the box." Adults enjoyed card games, rolling dice, hosting and attending dinner parties and dances and visiting the many taverns in the city. One could enjoy beer, wine and distilled liquor in the taverns, as well as a full course meal. Most of the taverns had slaves working in the detached kitchens cooking in the copper pots hanging on hooks in the giant fireplaces. They served roasted meats, shellfish and oysters (in season), soups, boiled seasonal vegetables and numerous confections, including cakes, pies, pastries and dumplings. Nearly every beverage one can think of could be found in these taverns, including spiced wines, brandy, whiskey, rum and beer. Men gathered in the taverns to talk, play cards and dice, throw darts, gamble and sometimes fight.

The citizens of Petersburg also enjoyed live theater. The Old Street Theatre, built in 1792 and located on the corner of Old and Grove Streets, drew in huge crowds on Saturday nights, and the Back Street Theatre alternated performances two or three times per week. Actors and actresses were paid two pounds per performance, and many of them became "local celebrities" in town. Mr. Thomas Warrell and his sons became a famous comedy act who performed "bawdy songs, drunken dances and hilarious comedic acts" in the Old Street Theatre. They had quite a large following of fans. Mrs. Eliza Poe performed in the Back Street Theatre numerous times

WELCOME TO PETERSBURG!

and became one of the most celebrated actresses in the city. She was employed full time from 1802 until 1810, when she moved away from Petersburg with her husband and son, Edgar Allan, who was born on January 19, 1809. Yes, *the* Edgar Allan Poe!

Thomas and Ann West were a married couple who performed at both the Old and Back Street Theatres from around 1800 until the theaters burned in 1815. Aaron Burr attended a play on the night of January 25, 1805, and described Mrs. Ann West as "the most distinguished ornament of the Virginia stage!"

While patrons enjoyed the plays at these theaters, they were also allowed to imbibe in spirits and beer. It was not unusual, therefore, for two constables to be placed at the entrance of each theater on show night in order to maintain law and order. Because alcohol was served to the patrons of the theater, drunken brawls were known to break out on occasion, sometimes during the middle of the performance.

Crime and Law Enforcement

The methods of punishment employed in Virginia up through the early nineteenth century were derived from English practices and included levying fines against the perpetrator, whippings at the public whipping post on the corner of Sycamore and Back Streets and capital punishment for crimes of a more serious nature.

Like any great city, Petersburg saw its share of crime. An examination of police blotters from the year 1815 in Petersburg indicates that most crimes were petty in nature—gambling, public drunkenness or theft. In 1815, Mr. Patrick Magruder was the justice of the peace. He came to this position after serving as deputy sheriff for several years and then as clerk of the House of Representatives. Mr. William Stark and Mr. M.E. Parish were deputies who ran the jail in the city, and several constables were employed to help keep the peace.

The town jail stood near the courthouse, but it was not meant to be a place of long-term confinement in 1815. Instead, it was a temporary holding cell until the miscreants could be brought before the magistrate. If they were arrested over the weekend, they went before the magistrate on Monday morning, when he heard the case and imposed sentencing, which was usually carried out immediately.

THE GREAT FIRE OF PETERSBURG, VIRGINIA

In the early nineteenth century, there was a very thick line drawn between the "haves" and "have-nots," and this line was not crossed, nor did the classes mingle with one another. In the spring of 1815, the constables were called to the Back Street Theatre because some free blacks had attempted to gain entry to the theater to see a play and were denied admittance. They got into an argument with the theater manager and were arrested for disturbing the peace. Some of these free blacks were business owners in the city, and yet they were still relegated to "the other side of town" at the end of the day.

The most common complaint on a typical Saturday night was a "drunken disturbance" in one of the taverns in the city.

One of the most common crimes was horse theft. The police blotters indicated dozens of horse thefts occurred every month, and bounties were often put on the heads of the horse thieves. Petty larceny was also a very common crime in the business district.

Muggings and robberies, while not as common as petty theft, did occur occasionally in Petersburg. On the night of June 18, 1808, a wealthy woman in the city complained to a constable that a man had held a gun on her and robbed her of her expensive jewelry, including a very valuable gold bracelet. Late in the evening of March 17, 1812, Mr. John Pegram was mugged by "several villains" and robbed of $100 in cash and a gold watch. The *Petersburg Intelligencer* reported that the sheriff was offering a reward for information leading to the arrest of the thieves.

On February 8, 1808, Mr. Davis reported the theft of several hogsheads of tobacco, and "a generous reward" was being offered for the return of the tobacco and the arrest of the thieves.

Some tavern owners reported money missing from their tills at the end of nights, and often an employee was arrested for this.

Domestic disturbances apparently occurred on a regular basis in Petersburg in the early nineteenth century. Each month, numerous women filed complaints with the sheriff stating that their husbands had physically assaulted them. In one day, December 18, 1805, six women filed complaints of physical assault by their husbands. By January 1806, four of these women had filed for divorce. The *Petersburg Intelligencer* ran a segment each week on who was filing for divorce or had filed complaints against their spouses. Not all were women complaining of men, however. On February 28, 1809, Mr. George Blick filed a complaint with the sheriff that his wife, Milleson Blick, who "had left me and says she won't live with me," was running up several tabs of debts in the city and not truthfully advising the merchants that she

WELCOME TO PETERSBURG!

was separated from Mr. Blick. He advised, in the newspaper advertisement, that he was not paying any of her debts. The ad ran the entire following week advising all merchants not to do business with Mrs. Blick.

On Thursday, May 5, 1808, a man named William Davis arrived in Petersburg "without money or property" and died shortly after arriving, according to the sheriff's report. Some citizens said they believed he might be from North Carolina, and he was estimated to be around age sixty, but nothing else was known about him. After a week, the *Petersburg Intelligencer* reported that a citizen by the name of Mr. John Fleming had come forward and paid to have Mr. Davis "treated decently" and offered a Christian burial in Blandford Cemetery after "attempts to locate any family have proven fruitless."

The newspaper also warned citizens of scams and swindlers operating in the city. For instance, a "swindler" by the name of Mr. Anthony Morales was arrested on June 18, 1808—he had been using the name "Mr. Dyde" and obtained money from several citizens "under false pretenses."

The previous week, a reward of forty dollars was being offered for information leading to Mr. Morales's arrest, and upon releasing his physical description, he was soon apprehended.

As was the case with most cities, children often engaged in mischievous behavior, including vandalizing property. Most engaged in simple "youthful follies" that included pranks and various acts of silliness attributed to their age, and the parents of these children were expected to make restitution in most cases. However, the child also faced penalties if the prank or act of vandalism was serious enough. Most were sorted out by their parents, but more serious cases usually resulted in the child receiving a whipping on the courthouse steps.

Although Petersburg was home to some of the wealthiest citizens in Virginia, some of the city's residents lived in conditions of abject poverty. Most were women and children. The local newspaper reported, each week, that petty thefts committed by children living on the street had occurred. Some were the children of impoverished mothers, and others were orphaned and did what they had to in order to survive. Many of them drifted into petty crime because they had no alternative.

Some orphaned children in Petersburg worked for an adult "fence" who sold the stolen goods and acted as a protector to the children. Some of the fences were the children's own parents.

On Wednesday, January 10, 1810, Mrs. Louise Williams, a widow, was arrested for stealing linens from Selby and Harned's Dry Goods Store

THE GREAT FIRE OF PETERSBURG, VIRGINIA

on Bollingbrook Street. Two young children were with Mrs. Williams, helping her carry the stolen goods from the store. According to the local paper, Mrs. Williams was homeless and had been engaged in acts of petty theft with her children for quite some time. She was found guilty of theft and vagrancy and sent to the local jail. Her two children were turned over to the orphan asylum in the city and indentured out to farms in the area.

On February 19, 1813, a ten-year-old boy, whose name was not revealed, was arrested for theft from a Petersburg merchant. He was later found to be a vagrant orphan and committed to the orphan asylum.

Though most people equate highwaymen with the seventeenth and eighteenth centuries, highway robbery was still a serious and very prevalent crime in early nineteenth-century Virginia. Railroads did not come into Virginia until the 1830s, so transportation was either by road or water in the early nineteenth century. Unfortunately, travel by highway was still dangerous in this era, as highwaymen often laid in wait on the main roads outside the city. Some worked independently, while others operated in gangs and held up stagecoaches, postal coaches and sometimes lone horse riders. Their usually famous demand was to "stand and deliver your money!"

On August 5, 1808, the mail carrier was accosted by highwaymen while riding through the back roads outside Petersburg carrying mail from North Carolina to Petersburg, and "several bank notes" were in the mail that evening. According to the police blotter, the highwaymen stepped in front of the coach, pointed guns at the driver and demanded that he stop. They then climbed inside the coach, grabbed the driver and pulled him out of the coach onto the ground, where several of the highwaymen beat him while a couple others were stealing the mail bags from inside. The mail carrier apparently tried to fight back, and one of the highwaymen shot him before they all fled on horseback. The mail carrier survived the attack, and a large reward was posted for the apprehension of the highwaymen.

A few suicides were noted in the police blotters in the early 1800s in Petersburg. Usually, the coroner was called on to perform an inquest to investigate the suicide, and he usually came back with findings of "temporary insanity" or "not of sound mind." One example was that of a Petersburg clerk who worked for a local accountant. He had been accused of stealing from his boss and fired in February 1815. Late that night, he walked down to the bridge that linked Petersburg to Pocahontas

WELCOME TO PETERSBURG!

Island, tied one end of a rope around one of the bridge anchors, tied the other end around his neck and jumped, hanging himself.

Though not as common in the eighteenth century, some men still engaged in duels with each other to settle a score or defend their or a dependent's honor. Dueling was illegal in the early 1800s, but it still occurred, as many men felt dueling was easier than trying to file a libel suit against their offenders. Duels were usually carried out by men of the upper classes. In fact, if a man from a working or lower class challenged an upper-class man to duel, the man of elite status usually walked away from such a challenge, considering it beneath him to duel somebody from a lower class.

Duels were witnessed by at least two or three people, and strict rules governed the behavior of the duelists. For instance, they could not engage in duels on a Sunday, they were required to salute one another before beginning the duel and they had to walk at least ten yards from one another before turning and engaging their pistols. The pistols could not be cocked before delivery, and each combatant could only fire one shot. If neither hit the other, the duel was considered over and both men were required to shake hands and declare that the offense had been forgiven. However, usually at least one of the combatants was shot, and some died from their injuries. One example of such a duel that occurred in Petersburg was between Mr. John D. Burke and Mr. Felix Cocquebert, who dueled over a political dispute on April 11, 1808, on the north side of Fleet's Hill. Mr. Burke was killed in the duel. Mr. Burke was a respected historian in the area and published *A History of Virginia from Its First Settlement* in 1804. He is buried in Cedar Grove Cemetery in the western end of Petersburg.

Another burial in Blandford Cemetery is that of thirty-four-year-old Captain John Jeffers. He was killed in a duel with Mr. John Johnson on Saturday, November 14, 1795.

A very common occurrence in the police blotters was escaped slaves. Nearly every week a report was made to the sheriff about a slave escaping from a nearby plantation or from a home in the city. The *Petersburg Intelligencer* ran ads on a regular basis about slaves who had escaped, giving physical descriptions of them, and most offered rewards for the apprehension of the escapees. Slave patrols were employed to locate escapees as well as to control the behavior of slaves in the area. One of their duties was to disperse slaves who were seen gathered together, which was a crime at the time, due to the threat of insurrections, which were

THE GREAT FIRE OF PETERSBURG, VIRGINIA

very common in the early nineteenth century. Most acts of insurrection were subtle in nature and consisted of running away, sabotaging tools, feigning sickness or deliberately slowing down the work in the fields. However, some acts of insurrection were of a more violent nature. In July 1812 in Petersburg, a man named John Poindexter was shot in the head while apprehending an escaped slave and died. A hue and cry was made and a large bounty put on the head of the escaped slave who killed Mr. Poindexter. No further information was found to indicate whether the slave was ever apprehended, however.

A few of the crimes in the blotter were of a far more serious nature. On July 3, 1810, a seven-month-old baby girl named Susan Tutbell was kidnapped. The child was described in the newspaper as having fair skin, light brown hair and freckles. A couple who had "drifted into town" trying to pass themselves off as a lady and gentleman were suspected of being the culprits. The sheriff ordered newspapers in other states, including Pennsylvania, New York, North Carolina and South Carolina, as well as all over Virginia, to run the story of the kidnapped child. The parents of little Susan were offering a $300 reward for the return of the baby, and the newspaper was asking for the public's help in "detecting a monster at large." Unfortunately, further research was unable to determine whether the child was ever found or the outcome of the case.

According to the *Petersburg Intelligencer*, on November 21, 1804, the body of an infant girl was found in the woods near the Blandford community. The medical examiner determined that the child had been born alive but was strangled shortly after birth. A few days later, another story ran stating that a teenaged girl named Nancy Landsdill had been arrested after several tips from some women came in to the sheriff. Miss Landsdill was arrested and examined by a midwife who found the girl had recently given birth. Miss Landsdill was charged with the murder of the baby. However, she escaped from custody. The mayor of Petersburg, Paul Nash, ran an editorial in the paper the following day asking every citizen of Petersburg "to make pursuit, hue and cry, after her so that she may be apprehended for the said unnatural crime and dealt with according to the law—to be hanged." A warrant for the girl's arrest was issued on November 24, 1804, but further records research does not indicate whether the girl was ever apprehended.

For a citizen to be charged with murder, an act of premeditation had to be proven. For instance, in August 1808, Mr. John Cody was hanged for the murder of his wife. Between 1800 and 1810, at least three slaves were

WELCOME TO PETERSBURG!

hanged for acts of insurrection against their masters, mainly plotting to kill the master. One was a female cook who poisoned her master's food, but the master only grew very sick and later recovered.

Some of the reports in the sheriff's blotter were about accidental deaths, such as the death of a ten-year-old boy visiting from Mecklenburg County on August 20, 1808. He had been playing by the Appomattox River with some other boys when he fell in. According to the newspaper article, a slave heard the screams of the children and ran to help. He pulled the boy back to shore, but all efforts to resuscitate the child were fruitless.

2
THE GREAT FIRE!

Sunday in the City

The legal and social dominance of the Anglican Church in Petersburg was unmistakable. The church operated under a system of vestries, a group of wealthy gentry who were elected from among men of the parish to run the local congregation's affairs. Such things as how much the minister was paid were determined by the vestrymen.

The eighteenth-century European Enlightenment had made its mark on Virginia, and by 1815, most of the citizens of Petersburg were subscribing to a more enlightened way of thinking. They had matured into a more secular people by the early nineteenth century, especially since the government had long ceased enforcing church attendance. However, only a small minority of people in Petersburg chose not to attend church each Sunday. But most attended to "see and be seen," exchange gossip and do business—for instance, they would exchange news about the going price of tobacco, slaves or horses. Sunday was a day of socializing and conviviality.

Sunday, July 16, 1815, dawned sunny with temperatures already around seventy-five degrees Fahrenheit and reaching a peak of ninety degrees that day. The citizens had begun waking early in order to enjoy a leisurely breakfast with their families before heading off to church later that morning. Breakfasts were usually large on Sunday mornings and included hotcakes, eggs, bacon, sausages, biscuits, gravy and grits.

People donned their finest apparel for church attendance—in 1815, women's dresses had become more decorative, skirts were fuller again and the corset had become a fashion necessity once more. The upper classes looked upon themselves as the guardians of the community's virtue and felt they had to set the standards of behavior for everyone else. Children were expected to remain quiet throughout the service, with women being put in charge of their supervision.

Church services usually lasted a few hours, and on particularly hot days, it became very uncomfortable inside the sanctuary. Ladies and gentlemen, regardless of the temperatures, were expected to wear complete outfits, including gloves and hats. By 1815, most people had set aside the tradition of wearing powdered wigs. Many ladies carried fans fashioned from silk and adorned with feathers, lace and faux jewels. On a particularly hot Sunday, the flapping of fans could be heard throughout the sanctuary. Some churches handed out paper fans with the words to certain hymns or local advertisements printed on the back. Children squirmed in their seats only to receive stern glances from their parents.

The Day of Rest

When the service ended, most of the citizens returned home to enjoy Sunday dinner in the early afternoon. The minister of the church dined with one of the local families, and it was considered an honor to host the minister at Sunday dinner. A great deal of preparation went into planning the Sunday dinner. Slave cooks ran the menu past the mistress of the home, and once the menu was approved, the meal preparation began. Some dishes were prepared a few days in advance, while others were cooked the night before or early on Sunday morning.

The invited guests began arriving for dinner around noon and were entertained in the drawing room or parlor with beverages and light snacks. The meal got underway around 1:00 p.m. with the master and mistress of the manor seated at opposite ends of the table facing each other and their guests seated on both sides of the table. As slaves brought out drinks and carried bowls of food into the dining room, the master, mistress and their guests engaged in stimulating conversation—in fact, the art of dinner conversation was considered an important skill among the affluent households in Petersburg. Children in middle- and upper-class homes were

THE GREAT FIRE!

taught table manners at an early age—sitting up straight in their chair, placing their napkin in their lap, not talking with their mouth full and the art of polite and interesting conversation. The southern states were the most polished when it came to table etiquette. In fact, Virginian William Fitzhugh stated that a child would be better off never born than being ill-bred.

The elite families were very fond of red meat, with roast beef being a particular favorite dish for Sunday dinner. They also enjoyed baked and fried chicken, roasted pork and fish. Some of the popular side dishes in the summer included fried squash, buttered sweet corn on the cob, collard greens, boiled cabbage and fresh baked bread. Desserts were also very popular, with baked pies and tarts being among the favorites.

After dinner, many men enjoyed riding, fox hunting or gathering with friends on the front porches of the homes to discuss politics and play musical instruments. Ladies often gathered in the parlor of the homes to drink tea served in delicate porcelain cups and play bridge.

An evening service was held in most of the churches, and most of the citizens attended these services, as well.

Sunday was usually a day of rest for slaves as well, especially on the plantations in the surrounding counties. Many free blacks and slaves alike attended church on Sunday in the city. Most of them were Baptists, and the most prominent churches were First Baptist Church, located on Harrison Street, which was built in 1774, and Gillfield Baptist Church, located on Perry Street and erected in 1797. Sandy River Baptist Church on Pocahontas Island merged with this church when it was built. Most slave cooks and domestic servants, however, were still expected to prepare meals for the master and his family on Sunday and to serve them and their guests during Sunday dinner. But toiling in the fields and factories usually did not happen on Sundays.

A Great Calamity

When evening services ended on the night of July 16, 1815, around 8:00 p.m., a breeze had begun kicking up from the east as a storm was brewing in the distance. Most of the citizens quickly returned to their homes to engage in the usual evening rituals. Some were enjoying a light meal of bread, fruit and perhaps a cooked egg dish, and many were partaking of a glass of apple brandy or wine. Many of the citizens believed that a drink before bed helped

THE GREAT FIRE OF PETERSBURG, VIRGINIA

ward off disease and promoted healthy circulation. Children were offered light snacks such as custard or egg dishes before being put to bed for the night. People were preparing for an early start to their next day, and most were retiring to bed shortly after their evening meal.

The shrieks of "Fire!" pierced the night air at around 9:30 p.m. As people emerged from their homes, they saw black smoke billowing from a stable located between Bollingbrook and Back Streets. The stable belonged to Mr. John Walker, who was frantically attempting to rescue his horses. Several of his neighbors had gathered to help fight the flames, but within minutes, the entire stable was completely engulfed in flames and the fire alarm was sounded.

The Old Street Fire Brigade responded to the scene and quickly began attempts to fight the blaze. Firefighting equipment in 1815 consisted largely of a horse-drawn carriage outfitted with buckets and ladders. Some fire brigades utilized hand pumps, but they required a great deal of manpower to operate them. Government-run fire departments did not exist in 1815, so private fire brigades responded to local fires and were paid by insurance companies for each building or home they managed to save.

An 1800s fire wagon. *Courtesy of Wikimedia Commons.*

THE GREAT FIRE!

As the easterly winds began to kick up, the flames leapt from the stable and onto the surrounding buildings in its wake. Most homes and businesses were built of wood and standing close to one another. The men of the fire brigade, as well as hundreds of volunteers, worked feverishly to fight the fires—they formed long lines and passed buckets of water to the front of each line. The buckets of water were thrown onto the fires, but the blaze soon became too strong to handle. Within the first hour of the fire, several homes on Bollingbrook were devoured by the flames, and the fire continued to spread up Back Street, over to Bollingbrook, down Sycamore Street and into Old Street and the market square.

The screams of desperate citizens rose above the din of the catastrophe unfolding. Majestic manor homes were collapsing with groans as flaming debris rained down on the people in the streets. Injured and shocked people were blindly trying to make their way through the thick smoke, stumbling over bodies strewn in the street, and some ran back into their burning homes desperately attempting to rescue family members but were immediately overtaken by smoke and flames. Terrified citizens leaped from top-story windows of their burning homes and fell to their deaths in the street. A man and his wife on Bollingbrook Street watched, helplessly, as all of their children burned to death in their home that was fully ablaze. The father, according to witnesses, had attempted to rescue his children, but the flames soon became too much for him to handle. The couple stood in shock, sobbing and screaming, along with several neighbors who witnessed the horrific event.

The fire continued down Old Street, burning most of the homes and businesses, and on to Sycamore Street, where it devoured magnificent manor homes and businesses. It raged through Back and Bank Streets, destroying hotels, churches, homes, grocery stores and the popular theaters. The flames quickly spread to Bollingbrook Street, taking out beautiful manor homes, grocers, an apothecary, a tobacco warehouse, a saddlery and several dry goods stores.

The flames continued to spread to the lumber house owned by Mr. Mabry and Mr. Dugger on Old Street, and within minutes the entire lumber house was reduced to ashes. Six adjacent homes on Old Street also perished in the fire, as did most of the homes and buildings on Back Street.

The *Petersburg Intelligencer* building on Old and Sycamore Streets burned, as did the printing office located beside it. The combustible chemicals inside the printing press caused a massive explosion that was felt for several miles. Three men were caught up in the explosion and instantly killed, while several

THE GREAT FIRE OF PETERSBURG, VIRGINIA

others were severely burned. One of those men was Samuel Myers, whose grave can be seen today near the front door of Blandford Church.

Across the Appomattox River, the citizens of Colonial Heights stood on the banks of the river at Fleet's Hill and watched, in horror, as their neighboring city was devoured by flames. A dull orange sky glowed eerily, and the shrieks of the wounded and dying remained etched in many witnesses' minds for the remainder of their lives. The taverns, Merchants Hall, all of the dry goods stores, grocers, apothecaries, hotels and offices were reduced to ashes in the fire. Some businessmen tried, in vain, to rescue important documents and materials from their offices, but the flames became too powerful and they were forced to leave everything to burn.

At around 2:45 a.m. the next morning, a flash of lightning zipped across the sky and was soon followed by a rumbling ball of thunder and a downpour ensued, but it came too late to quench the flames. By that hour, most of the city of Petersburg was gone. Many of the citizens later told the reporters who covered the stories that the shrieks and screams of agony weighed heavily on their minds as they watched their once glorious, beautiful city burn to the ground.

3
THE IMPACT OF THE FIRE

A Prosperous City

Prior to the fire in 1815, Petersburg was one of the most important cities in Virginia. It employed thousands of people, including the local planters who rented out their slaves to work in the tobacco factories of the city, one of Petersburg's most important industries. By 1815, Petersburg had developed into the major tobacco center in Virginia. It was the site of the most important tobacco grading stations in the South. Nearly one million pounds of tobacco was processed in Petersburg and shipped to markets up and down the East Coast and overseas. Tobacco merchants sold pipes, cigars and other smoking apparatuses, and the tobacco industry was one of the most important in Virginia.

Surrounding cities, including Richmond, Alexandria and Fredericksburg, were transfer points for tobacco shipped from Petersburg by the Appomattox and James Rivers. Tobacco was packed into wooden hogsheads and shipped along the river ways in flat-bottomed "Petersburg Boats" designed to carry ten to fifteen hogsheads of tobacco at a time to several neighboring states, including Georgia and Kentucky. And the tobacco trade between Petersburg, Virginia, and England and Scotland was one of the staple exports from Petersburg. London was the major port of entry in England and Glasgow the major port in Scotland. The quantity of tobacco being shipped to Great Britain from Petersburg numbered in the hundreds of thousands of barrels each year and helped to create some of the wealthiest families in Virginia right in the Petersburg area.

THE GREAT FIRE OF PETERSBURG, VIRGINIA

Important Exports

In addition to tobacco, Petersburg also exported over 600,000 barrels of other products each year, including lumber and flour and grain that were processed in the mills in Petersburg. These trade exports, which resulted in over $1 million in revenue each year, kept the city alive. In fact, Petersburg had been enjoying one of the highest periods of growth in the trade and export business since the American Revolution. One of the most important exports from Petersburg, besides tobacco, was shoes. Several local shoemakers in the business district mass produced shoes that were exported throughout the other colonies, and shoemakers in England found it a struggle to compete with the shoemakers in Petersburg. Shoes made in Petersburg were exported to Richmond and Fredericksburg as well as North Carolina and some points as far north as Massachusetts.

Furniture made in Petersburg was also an extremely important export. Not only did people from the Petersburg community rely on the furniture craftsmen to furnish their homes and businesses, but the master furniture craftsmen produced furniture of such high quality that it was exported to other colonies, as well. In fact, since 1760, the furniture craftsmen had been an integral part of Petersburg's economy, and the business was thriving by 1815. The wide range of furniture styles, including Windsor, kept the Petersburg furniture craftsmen in high demand. By the year 1800, Petersburg's furniture industry had expanded into large-scale operations that moved up into the northern cities and down into the southern states. The rapid economic growth had encouraged the exportation of the locally crafted furniture.

Petersburg-made coaches were also in high demand. Petersburg had a substantial coach-making industry that rivaled that of Williamsburg. Craftsmen in Petersburg specialized in creating work carts, wagons and coaches that were properly painted and trimmed. In fact, some of the wealthiest families in Virginia ordered coaches to be made by Petersburg craftsmen. They were outfitted with velvet seats, painted, gilded and varnished, with decorative trim and coats of arms painted on the doors. The wealthy inhabitants of Virginia and surrounding colonies recognized the Petersburg craftsmen as some of the best in the country, and the industry brought a great deal of revenue to Petersburg.

Because of its advantageous location, Petersburg had been steadily expanding its regional influence and offering a large array of locally made products for cash or trade—such as cash crops like wheat and tobacco.

THE IMPACT OF THE FIRE

Some of the other most important occupations in Petersburg included saddle makers, weavers, tanners, tailors, cobblers and blacksmiths.

A City of Culture and Prosperity

Petersburg also offered a wide array of cultural events that drew large numbers of people to the city each year. During its years of great prosperity from the 1760s up until the fire of 1815, Petersburg had attained a wide array of essential services, including a newspaper, the *Petersburg Intelligencer*; a post office, which began operating in 1795; a great number of hotels and taverns; prestigious schools that drew in students from all over the area; and numerous mercantile firms, including cabinet and furniture makers, tailors and dressmakers, haberdasheries, seamstress shops, grocers and dry goods merchants. The city also had an important town hall, and some of the most prestigious doctors, politicians and lawyers in Virginia called Petersburg their home.

The city of Petersburg was also an important cultural area, offering some of the most prestigious social events in the state. Important presidents, senators and military leaders traveled to Petersburg to attend lavish balls, promenades, plays and community events.

Devastating Losses

The losses of the fire were not only felt in Petersburg but also in the surrounding states and as far away as Great Britain. Tobacco, wheat, cotton and other grains were grown on the neighboring plantations and sent to Petersburg to be processed and shipped. The numerous warehouses holding these goods burned in the fire, destroying hundreds of thousands of dollars in merchandise. This had a devastating effect on the local planters as well as the local economy. Neighboring towns and states that relied heavily on the exportation of these goods also felt an enormous impact from the losses. This included the exportation of shoes, coaches, wagons, cabinets and furniture. In addition to the loss of lives, the fire of 1815 caused a major economic loss to the planters of neighboring counties, as well as neighboring cities and states, that would be felt for a great while.

4
RISING FROM THE ASHES

Monday, July 17, 1815, dawned, and the grim task of surveying the damage began. Wounded people staggered hopelessly through the streets searching for missing loved ones. Babies and children could be heard screaming and crying for parents they would never see again. Volunteers from neighboring counties arrived to help clear the debris in search of the wounded and dead. As the day progressed, more bodies were discovered under the debris and were loaded away in horse-drawn carts.

It was determined that two-thirds of the city had been burned to the ground. A total of over five hundred homes were lost, including the stately eighteenth-century manor homes of Petersburg's wealthiest citizens such as the Bollings, Lynches, Gathers, Braggs, Joneses, Bowdens, Haxalls, Friends, Petersons, Gays, Jarratts, Randolphs, Dunlops, Ruffins, Stewarts and Botts. In fact, the only house still standing in a four-block area was the home of Mr. John B. Read on Bollingbrook Street because the home was constructed entirely of brick. Two brick homes remained standing among the ruins—John Peniston's home and John Read's row house were virtually untouched by the flames.

The Petersburg Mutual Insurance Company estimated total damages to be over $3,000,000. A complete list of all homes and businesses listed in the insurance records appears in the appendix at the end of this book. The list includes all of the groceries, the bank, taverns, newspaper office, apothecaries, milk bottling plant, hotels, dry goods and mercantile shops and all of the theaters.

THE GREAT FIRE OF PETERSBURG, VIRGINIA

A home built in 1814 of brick that did not burn. *Courtesy of Jeff Seymour.*

Over the following week, the search continued for more victims. The exact number of people killed was never determined, but charred remains of victims were found strewn throughout the city. In several cases, only a few bones and ashes were located amid the ruins. Witnesses to these horrific days described the constant sound of sorrowful sobs and agonizing screams as bodies were positively identified and their loved ones were notified. Desperate family members gathered in the common areas, hoping to hear news about missing loved ones. Meanwhile, volunteers continued to sort through piles of smoldering debris as the overpowering odor of death and decay surrounded them. On Bollingbrook Street, the charred remains of an unidentified woman were found lying in an alleyway where the home of Mrs. Ephram Geddy once stood. Mrs. Geddy owned several boardinghouses and operated the estate auctions business in town. Because Mrs. Geddy was never seen again after the fire, it is believed that the charred remains were hers. Several bodies were located in the business district. In total, however, only twenty-eight bodies were recognizable enough to be positively identified.

Newspapers all across the country reported the devastating fire in Petersburg. The *National Gazette* reported, "A few days ago the town of Petersburg was prosperous and flourishing—commerce crowded its wharves—a busy population thronged its streets—and new buildings, daily

erected, announced its increasing wealth and importance. In one awful night the whole scene was changed; a fire…has involved the larger portion of our citizens in distress, and reduced many of them to beggary."

Appeals were made by the mayor of Petersburg to other towns for assistance. Volunteers from surrounding cities and counties as well as neighboring states began arriving in Petersburg in the following week to assist the victims of the fire. People in surrounding counties opened their homes and offered rooms to those left homeless by the fire. Churches in neighboring counties and cities sponsored food and clothing drives, and companies from varying states offered to help rebuild and donated money to help defray the building expenses. The Artillery Fencibles Company of Baltimore donated $500, a church in Maryland raised $1,000 and $5,000 was raised by the Society of Believers in New York, now known as Shakers. Hundreds of dollars were raised by churches in Richmond, Hopewell, Prince George, Chesterfield County and Dinwiddie County. A school in Richmond raised $500, and nearly $4,000 was raised by one church in Atlanta, Georgia. In all, nearly $125,000 was collected through relief drives for the victims.

While volunteer carpenters hammered away reconstructing the city, women's groups and churches from nearby towns served meals to the workers. Undertakers from Richmond, Dinwiddie and even as far away as North Carolina began arriving in the city to help with the massive task of burying the victims. Some of the victims were laid to rest in private family graveyards in the surrounding counties, and a few were buried in Blandford Cemetery, including Mr. Samuel Myers, the Baltimore native who was one of three men killed in a massive explosion in the Sycamore Street printing press. His tombstone can still be seen near the front of Blandford Church. It reads, "Sacred to the memory of Mr. Samuel Myers, a native of Baltimore, who perished in the Great Fire of Petersburg on July 16, 1815."

Funerals in the early nineteenth century were very solemn occasions. Initially, messengers were sent out on horseback and by boat to notify friends and relatives in neighboring counties and states that a death had occurred. Most churches had graveyards behind them that were consecrated, including Blandford. The congregation usually took responsibility for helping with the graveyard's upkeep.

With no effective means of preserving dead bodies in 1815, funerals were usually held as soon as possible after a death occurred. On private plantations, only the "lower sort" were buried in a churchyard, while the wealthy family members were laid to rest together in a private burial ground on the plantation. The family members took charge of preparing the body

THE GREAT FIRE OF PETERSBURG, VIRGINIA

for burial, including washing the corpse and wrapping it in linen. After the fire, coffin makers from several neighboring counties brought coffins into Petersburg for the funerals.

A wake was usually held the night before a funeral, and the coffin was normally open when people visited the family home. However, due to the gruesome factors of the fire, including the fact that most of the bodies were rendered unrecognizable, most of the coffins were closed, and the private wakes did not take place; there was simply no time for such rituals that week. Usually, the tolling of local church bells signified the start of a funeral—however, nearly every church in Petersburg burned in the fire, so it's unlikely the tolling of bells was heard that week. Pallbearers—usually neighbors and members of the deceased's church—gathered on the day of the funeral, and many of the volunteers served at several funerals that week. The pallbearers loaded each coffin onto a horse-drawn hearse. The coffin was wrapped in a pall and placed on a bier before being loaded into the hearse.

Some of the wealthier families of Petersburg exercised as much pomp as necessary for the funerals of their deceased loved ones. The hearse was pulled by plumed horses driven by men dressed in long black cloaks bearing painted banners. The coffin was laden with escutcheons and plumes and covered in a canopy. Behind the hearse marched the procession. For very wealthy or important members of the community, the funerals could be quite large and expensive. People marched in the funeral procession according to rank, with the wealthiest gentry marching at the front of the line and members of a society or profession—such as lawyers or doctors—marching together.

Because the bodies needed to be buried as soon as possible, the volunteer ministers delivered eulogies in the graveyards, while more graves were being dug all around them. At the grave site, the coffin was removed from the hearse and placed beside the open grave. The minister spoke over the coffin as it was laid in the ground by the pallbearers. As soon as one coffin was lowered into the ground, the undertakers were off to see to another funeral. Mourners laid flowers on the coffin after it was lowered into the ground. When the mourners dispersed, the grave attendants covered the grave with dirt. Temporary markers were placed over the graves while orders for engraved tombstones were being filled. Many tombstones in this era reflected the life story of the deceased or told how the deceased died, such as the grave of Samuel Myers. Most tombstones were carved of slate, sandstone, granite or marble. Most funerals took place during the day, but Anglican processions occurred at night with candles lighting the way to the cemetery.

RISING FROM THE ASHES

Example of an 1800s hearse. *Courtesy of the Library of Congress.*

After the funerals, mourners met at various homes to feast and drink. It was a time of socializing for most citizens. However, during the week that the fire victims were being buried, it is unlikely that the survivors had the time or inclination to visit with one another. The bodies were buried as hastily as possible, and some engraved tombstones were likely not placed on the graves for up to another year after the fire.

Newspapers across the country wrote of the disaster in days following the fire, including the *Niles Weekly Register* on Saturday, July 22, 1815:

> *Dreadful fire at Petersburg, V.—a fire broke out at Petersburg, Virginia on Sunday evening last at about 8 o'clock which could not be checked until four hundred houses (such is the estimate!) were destroyed! It is also believed that 28 to 30 persons have lost their lives…We have not yet the terrible particulars but would hope the accounts are exaggerated.*
>
> *The sound of alarm bells rung our ears—the flames were instantly seen burning from the stable belonging to Mr. J. Walker, between Bollingbrook and Back Streets—the surrounding buildings being entirely of wood, standing near to each other, were seized in a moment by the devouring*

element, and communicated it to others with the rapidity of lightening [sic]. *The loss of goods and furniture is incalculable—and what adds poignancy to the grief is that there was a slight breeze from the east. Many lives were lost—their bones are to be seen among the ruins, but it is not known who the sufferers were.*

A thorough investigation into how the fire started began right away. The owner of Brewer's Tavern on the corner of Bollingbrook Street and Back Street told investigators he was outside the rear of the tavern around 9:30 p.m. when he smelled smoke. Suddenly, he noticed Mr. Walker's stable, next door, was on fire. He also claimed to have seen five of Mr. Walker's slaves running from the stable at a fast pace and was able to identify the men he saw that night. Initially, the slaves denied the tavern owner's claims but then recanted and admitted they had been playing a game of cards and had accidentally knocked over a lantern. The question arose as to whether the slaves were actually gathered together in order to plan an act of insurrection, but the slaves adamantly denied this. However, it was illegal for several slaves to gather together in secret, and though the men were charged with starting the fire, no record exists of what punishments ensued.

On August 6, 1815, the steamboat *The Chesapeake*, captained by Andrew C. Trippe, arrived in the area in order to offer excursions with all proceeds going to help the victims of the fire.

Over the next year, new homes and businesses were built in Petersburg—and insurance regulations required that they be constructed of stone and brick from that point. At the same time the new construction was underway, the roads were straightened and widened. Bollingbrook had been the first paved street in Petersburg in 1813, and it was resurfaced.

5
MOVING TOWARD THE TWENTY-FIRST CENTURY

PETERSBURG'S REVIVAL

Immediately after the fire, architects, engineers, building contractors, brick masons and stonemasons from neighboring cities and states descended on Petersburg and began building some impressive, noteworthy structures. These included the new courthouse, which was designed by New York architect Calvin Pollard; the Tabb Street Presbyterian Church, designed by architect Thomas U. Walter and built by Dabney Cosby; the customs house; and several more churches, including St. Paul's Episcopal Church. Several taverns and hotels were built to replace the ones lost in the fire, including the exclusive Bollingbrook Hotel, which opened in 1827 and was soon declared the finest hotel on the Atlantic seaboard.

Over five hundred homes and nearly one hundred businesses were destroyed. Many of the new homes were as magnificent as, if not more so than, before. After insurance money was collected, builders were contracted to start erecting new homes, and within a year, over three hundred new homes had been rebuilt. Most of the homes were two and three stories and of the Federal and Greek Revival styles with simple doors and windows yet elaborate ornamentation around them. Curved steps leading up the grand homes became a common feature, and many of the homes featured tall columns on the large front porches. Iron fences were erected around many of the homes. Many homes featured detached kitchens at the back, and some had servant quarters located in the attic or basement of the detached kitchens.

THE GREAT FIRE OF PETERSBURG, VIRGINIA

Cockade Alley, Petersburg. *Courtesy of Jeff Seymour.*

Example of rebuilding after fire—behind the alley of Siege Museum. *Courtesy of Jeff Seymour.*

MOVING TOWARD THE TWENTY-FIRST CENTURY

Some of the most well-respected builders and craftsmen in the state of Virginia converged on Petersburg to help with the rebuilding of homes and businesses. They included John Neilson and James Dinsmore, both of whom had worked on Monticello with Thomas Jefferson. The mayor of Petersburg, Nathaniel Friend, had a new home erected in early 1816 to replace his home that had burned in the fire. The home of wealthy politician George Jones, which was built on Cockade Alley in 1794 by Erasmus Gill, burned and was rebuilt in 1816. Jones went on to become mayor of Petersburg. The home is a two-and-a-half-story Federal frame dwelling with a one-and-a-half-story wing. In 1831, it was purchased by Archibald McIlwaine, a Petersburg industrialist and financier.

In the eastern end of Petersburg, several row houses were constructed after the fire. The commercial district was rebuilt, as well, and included new taverns and hotels, restaurants and coffee shops, dry goods stores, mercantile and various service industries. An ironworks and a major tobacco processing plant were erected alongside several tobacco warehouses. A new courthouse and jail were erected, and the burned churches were rebuilt. The Old Street Theatre was rebuilt by late 1816, renamed the Petersburg Theatre and began offering performances once again. Engineers straightened out the new roads, widened them and paved several more.

Former grocery stores on Old Street, now restaurants and antique shops. *Courtesy of Jeff Seymour.*

THE GREAT FIRE OF PETERSBURG, VIRGINIA

Left: Petersburg in the early nineteenth century. *Courtesy of the Library of Virginia.*

Below: Rebuilt Petersburg, Virginia. *Courtesy of historicpetersburg.com.*

Demographic studies decades later revealed that Petersburg's population swelled from 8,322 in 1830 to 14,010 in 1850. By 1854, the population was estimated to be 18,000, placing Petersburg third in Virginia with respect to population.

Just prior to the Civil War, the city built a racetrack, several new theaters and numerous hotels and taverns and is said to have overshadowed Richmond in popularity. Petersburg's unchecked growth during the first half of the nineteenth century was stimulated greatly by the arrival of the railroad in 1830. Sixty miles of track were laid by the Petersburg Railroad to Weldon, North Carolina, by 1833. Other railroads quickly following

MOVING TOWARD THE TWENTY-FIRST CENTURY

were the City Point Railroad (chartered in 1836), the Southside Railroad to Lynchburg (completed in 1854) and the Norfolk and Petersburg Railroad through the Dismal Swamp (completed in 1858). These railroads, coupled with the extensive routes of the upper Appomattox Canal Company, made Petersburg a major transportation center for the South.

INTERSTATE SYSTEM

Beginning with the rebuilding of the city after the devastating fire, the city began paving more of its streets. Initially, only Bollingbrook had been paved. A development company created a canal to bypass the Appomattox Falls shortly after.

In 1816, the first turnpike from Petersburg to Richmond was built on Route 1, which was named Jefferson Davis Highway after the Civil War. Taverns and hotels were built all along Route 1 to cater to travelers along the new turnpike because travel from Petersburg and back again could take most of the day in the early nineteenth century. There had already been a stage route from Halifax, North Carolina, to Petersburg built in the eighteenth century. The new turnpike began at the corner of Bollingbrook Street, cut over to Bear Alley, across the bridge into Colonial Heights and up Route 1 into Richmond. This was great news not only for the new taverns and hotels being built but also for well-established taverns and inns, such as the Halfway House, built on Route 1 in 1760, and Howlett's Tavern in Chesterfield County. Many of the taverns also offered rooms for rent upstairs.

As travel technology developed in the mid-nineteenth century, railroads began to link Petersburg to all points of the compass, and the city soon became a major railroad center with lines running to Richmond in the north, Farmville and Lynchburg to the west and North Carolina to the south. The last major line was completed in 1858 to the east with the connection of the Norfolk and Petersburg Railroad to an ocean port.

In the late 1950s, the Richmond-Petersburg Turnpike was opened and joined the U.S. Interstate Highway System. By 1958, Petersburg had been named an "All American City" for its high quality of life for its citizens. The interstate system helped the retail and industry prosper as a large number of new homes and sprawling subdivisions were being built throughout the city to meet the demands of the large numbers of people moving to Petersburg

to take high-paying jobs. Tobacco was still the chief economic crop of the state, with Brown & Williamson Tobacco Company being the top employer in Petersburg.

Electrifying Process

In 1851, the city introduced gaslights and by 1857 had installed a new municipal water system. All of these civic improvements helped attract and hold a substantial business community, based on manufacture of tobacco products but also including cotton and flour mills and banking.

The Virginia Electric and Power Company (VEPCO) erected the Electric Building near the Appomattox River in 1922. VEPCO ran the inter-urban trolley system that ran from Petersburg to Richmond each day as well as provided electricity for thousands of homes and businesses in the city.

Early twentieth-century Sycamore Street. *Courtesy of cardcow.com.*

The Siege of Petersburg

Because of these railroad networks, Petersburg became the key to Union plans to capture the Confederate capital at Richmond, Virginia, during

MOVING TOWARD THE TWENTY-FIRST CENTURY

the American Civil War. A nine-month siege in 1864 and 1865 occurred in Petersburg, and today battlefield sites throughout Petersburg have been preserved through the National Park Service and the Petersburg National Battlefield. These places tell a story of a time of struggle not only for the Confederate army but for the citizens of Petersburg, as well. This siege began with the Union army descending on Petersburg and brought a great deal of physical damage to most of the buildings that had been erected after the fire of 1815. They cut off the railroad supply lines through Petersburg to Richmond and constructed trench lines that extended over thirty miles from the eastern outskirts of Richmond to the southern outskirts of Petersburg. Many of the businesses in the Old Town district were damaged by Union shells during the siege, including the grocery stores. This left the civilians in a very bleak situation. A citizen of Petersburg wrote in her journal that "drunken, giddy Union soldiers were destroying much of the personal property of the civilians."

The tobacco industry, which had begun to thrive again since the fire of 1815, closed down during the Siege of Petersburg. Most of the tobacco warehouses were converted into hospitals or prisons.

As the food supplies were cut off, starving citizens became desperate. At the same time, nearly every stray dog, cat, rat, squirrel and pigeon disappeared from the city as some street vendors were selling meat pies for a penny. They weren't disclosing what *kind* of meat was in the pies, and the hungry citizens were asking no questions. Mrs. Pryor, a prominent Petersburg lady, stated in a journal she kept that she went to purchase a meat pie one day only to see a dead, freshly butchered mule lying alongside the table where the meat pies were displayed. The local churches set up soup kitchens and offered bowls of soup or cooked cabbage to long lines of hungry, desperate citizens. Women from the churches volunteered as nurses and seamstresses for the Confederate army.

As a result of the sky-high prices and the inability to obtain many goods, looting became rampant during the siege and Union bombardment. Many once upstanding citizens of the city turned to theft and began robbing homes and stores, looting smokehouses and stealing vegetables from gardens and liquor, coffee and whatever they could get their hands on from any stores that still had goods. Desperate people started raiding farms at night, stealing eggs, chickens, vegetables and whatever else they could find. Farmers were forced to stand guard over their farms day and night in order to protect what they still had.

The wealthiest citizens of Petersburg could continue to purchase whatever they wanted from surrounding counties and cities, but for a very high price.

THE GREAT FIRE OF PETERSBURG, VIRGINIA

The laws of supply and demand reared their ugly head, and prices skyrocketed—making everyday items virtually out of reach for ordinary or poor citizens and even difficult for many wealthy families. Examples of this are butter selling for twenty-five dollars per pound and a pound of beef for fifteen dollars. A dozen eggs sold for six to ten dollars, and one chicken could run you fifty dollars. A dozen apples were four dollars, and a cigar ran ten dollars.

The wealthy citizens also attempted to keep life as near normal as possible during the siege. Some of the elite families began hosting "starvation balls," whereby they'd invite other elites from the city to a "dinner" in which there was not a morsel to eat or drop to drink, except water from the Appomattox River—which was nicknamed "Jefferson Davis Punch." One of the most elegant hotels in Petersburg, the Hotel Bollingbrook, also began hosting several "starvation balls" during the siege. The advertisements for the balls, hosted for the Confederate troops and citizens, stated that there would be "dancing, gaiety and fun, but no food or drink."

A few minutes after 4:00 a.m. on July 30, 1864, the citizens of Petersburg were shocked awake by a thunderous explosion that shattered windows all over the city. It turned out to be eight thousand pounds of powder exploding beneath the Confederate encampment near what is now Fort Lee.

Several upper-class Petersburg families would invite the Confederates to dine in their homes on Sundays and holidays. They laid out their best china, silver and linen, but because of the scarcity of food, they served boiled potatoes, corn bread, maybe a slice of bacon and coffee made from dried sweet potatoes and sorghum molasses.

Christmas dinner of 1864 was hosted for some of the Confederate troops in some of the homes of the Petersburg elite. The dinner menu usually was sparse by then and consisted of only bacon, corn bread, black-eyed peas and a pie made from dried apples.

The winter of 1864 was one of the coldest in Virginia, and the Union army made it difficult for fuel to get into the city. Citizens began burning their furniture to stay warm. Then they tore down the city's defense post and burned that, too.

After the Civil War, the period of Reconstruction began. William Mahone, a former Confederate general, became the driving force to combine the Norfolk and Petersburg, South Side and the Virginia and Tennessee Railroads to form the Atlantic, Mississippi & Ohio Railroad (AM&O), which extended from Norfolk, Virginia, to Bristol, Tennessee. In 1881, the railroad was sold at auction and became part of the Norfolk and Western Railway.

Moving Toward the Twenty-First Century

Higher Learning

After the fire of Petersburg, the city saw a large number of schools being built. Most of them were private schools for boys and girls, including seminary schools and dame schools. The first privately funded junior college for girls, the Southern Female College, was built on South Sycamore Street in 1863. For over seventy-five years, this college attracted young women from all over the state and several neighboring states.

In 1868, the city's first high school was opened in the former Classical Institute building on Union Street. The school was for white students only.

In addition to the all-white high school, five grammar schools opened in Petersburg for white students, including Duncan M. Brown Grammar School, which was opened on Wythe Street in 1908, named for Petersburg's first school superintendent, who served from 1886 to 1908. The school was described, at the time, as being the most modern building in the state of Virginia, and the design of the building was replicated in several future grammar schools in years to come.

Two other grammar schools opened on West Washington Street—Robert E. Lee and Stonewall Jackson Grammar Schools, both in 1910. Robert E. Lee Grammar School had fifteen classrooms, a large auditorium and a dining room. Stonewall Jackson Grammar School had two floors and an auditorium on the second floor.

In 1918, a new high school was erected on West Washington Street, built in the Greek Revival style. The school was state of the art for its time and featured biology, physics and chemistry labs; a library; a sewing room; an auditorium that seated over one thousand; a gymnasium; and two cafeterias. However, in September 1918, the deadly influenza epidemic struck Petersburg. The start of the school year was rolled back because the school was used as a makeshift hospital to treat the countless victims of the disease. The influenza epidemic caused the closure of several schools and businesses, and the state fair was cancelled that year. On October 11, 1918, state officials estimated that nearly 200,000 cases of the flu had been reported, but because they were unable to track the epidemic effectively, the actual number was likely much higher. By the end of October 1918, the epidemic had passed, and Petersburg High School officially opened. The all-white school was desegregated in 1970. A few years later, a new high school was built on Johnson Road. In 2000, the old high school on Washington Street became the Appomattox Regional Governor's School for the Gifted.

THE GREAT FIRE OF PETERSBURG, VIRGINIA

Anna P. Bolling Junior High School was opened in 1926, named for a former teacher and the former principal of Petersburg High School from 1868 to 1907. The building was one of the most advanced junior high schools in the state, containing science labs, an auditorium that seated nearly one thousand, a gymnasium and a dining hall.

General Mahone had also been a major proponent of public schools for the newly freed blacks in Petersburg. In 1874, Peabody High was opened at 35 West Fillmore Street. It was the first public high school for blacks in Virginia and one of the first in the nation. Many of Peabody's students later were at the forefront of the civil rights movement, including taking part in the city's first sit-in at the public library. Mahone also made arrangements for the proceeds of AM&O sales to fund a teachers' college for blacks in Ettrick, just outside Petersburg. In 1882, the Virginia Normal and Collegiate Institute was founded. Today, it is known as Virginia State University.

THE FREEDMEN'S BUREAU

The Freedmen's Bureau established several new facilities in Petersburg during Reconstruction. This included Howard's Grove Hospital, built at the site of a former Confederate hospital, and the Central Lunatic Asylum, an organized state mental institution for free blacks, built on the site of the former Mayfield Plantation.

In 1874, James M. Wilkerson Sr. founded the Wilkerson Undertaking Company, one of the first black-owned funeral homes in the United States. The funeral home continues to operate today.

SEPARATE BUT EQUAL

The late nineteenth through the mid-twentieth centuries saw the enactment of the Jim Crow laws, which imposed racial segregation throughout the city. Not only were the schools segregated but most of the businesses and restaurants were as well. African Americans were also barred from the use of many public spaces and facilities.

The world wars led to the construction of Camp Lee near Petersburg, and soon after World War I ended, the camp was established for training new

draftees. During World War II, Camp Lee saw a surge of new construction on the site, and in 1950, the base was renamed Fort Lee and became home to the U.S. Army Quartermaster Corps. Many African Americans had served the nation during both world wars, and they began to press for social justice and an end to segregation on the military base.

First Baptist Church and Gillfield Baptist Church formed the moral center for the civil rights movement in Petersburg and were the major centers of action during the movement. The pastor of Gillfield Baptist Church, Dr. Wyatt T. Walker, was close friends with Dr. Martin Luther King Jr., and in 1957, they co-founded the Southern Christian Leadership Conference (SCLC). Dr. King visited Petersburg several times in the 1950s and 1960s. Numerous sit-ins occurred in various places, including the Petersburg Bus Terminal, which was located on West Washington Street, and lunch counters, including Woolworth's on Sycamore Street. Petersburg was the first city to designate Dr. Martin Luther King's birthday as a holiday, and it later became observed as a national holiday.

The early 1970s brought major changes to Petersburg with the desegregation of all the public schools and housing areas. But many of the upper-middle-class white families soon left Petersburg and moved to neighboring Colonial Heights and Chesterfield County. At the same time, many of the businesses in Petersburg began to move farther south, where the wages were lower, including Brown & Williamson, which relocated to Macon, Georgia, a market with lower taxes. The public schools also saw a downward trend in school enrollment numbers over the next couple decades.

A Retail Renaissance

In the late 1960s, a shopping mall was built in the Crater Road commercial corridor of Petersburg. The 300,000-square-foot mall had two anchor stores, Thalhimer's and Rucker-Rosenstock's. It also featured Sears, J.C. Penney and several other merchants throughout the weather-controlled "Shopping Showplace of Southside Virginia." This mall brought Petersburg the reputation of being a major retail metropolis, with several of the local stores having moved from downtown Petersburg into the mall. The mall also featured a brand-new movie theater built nearby on Walnut Boulevard that opened on February 9, 1967, featuring a 50-foot screen and seats that were

advertised as "Living Room Comfort." The first film shown there was *The Gambit*, starring Shirley MacLaine and Michael Caine. The theater attracted viewers from the local area as well as neighboring cities and towns.

From Boomtown to Ghost Town

The beginning of the end occurred in 1989, when a brand-new shopping mall was opened in Colonial Heights, Southpark Mall. Several of the merchants and the most important anchor stores left Walnut Mall and relocated to Southpark Mall. The once vibrant Old Town area had already begun to decline by that time and became a virtual ghost town by the early 1990s.

The early twenty-first century saw resurgence in Petersburg. Petersburg leaders began highlighting the city's important historical value, and by 2007, the Old Town district had begun to experience an economic boom.

Business Booming Once More

A visitor to Petersburg, Virginia, today will find that much of the past still remains, due to the tireless efforts of the Historical Petersburg Foundation. The Old Town district today is a vibrant mix of restaurants, cafés, antiques galleries, government offices, businesses and private residences. The Petersburg Area Art League features many exciting events throughout the year, and the significant eighteenth- and nineteenth-century architecture has made this district a "Little Hollywood" due to the number of period films that have been made in Petersburg. The city has been used as a backdrop for the films *Lincoln* and *Ithaca* and several TV productions, including PBS TV's *Insurrection* and AMC's *Turn*. Directors, including Tom Hanks, Meg Ryan and Steven Spielberg, have discovered Petersburg as an ideal city for making period films, and the movie industry has breathed new life into the city.

Some of the most important historical sites in the state are located in Petersburg, including the 1817 Farmer's Bank, one of the oldest surviving bank buildings in the United States, and Blandford Cemetery, dating to the late seventeenth century.

MOVING TOWARD THE TWENTY-FIRST CENTURY

Right: The Farmer's Bank, built in 1815 after the fire. *Courtesy of Wikimedia Commons.*

Below: The farmers' market as it looks today. *Courtesy of Wikimedia Commons.*

THE GREAT FIRE OF PETERSBURG, VIRGINIA

There have been many disasters to hit the city since the fire of 1815, including a devastating tornado that struck Petersburg on August 9, 1993, that nearly demolished Pocahontas Island and several historic buildings in the city, including the Peter Jones' Trading Post on Market Street. But one thing can never be destroyed: the resilient spirit of the people of Petersburg.

APPENDIX

Prominent Families

Petersburg, by 1815, was already home to some of the most important families in Virginia. While the list of every notable family is very long, following are some of the most notable families:

Edward Jones, the great-grandson of Peter Jones, whom Petersburg was named for, was a very wealthy tobacco merchant in Petersburg. He and his wife, Martha, and five children lived in one of the most elegant homes in the city. The Joneses also owned a great many slaves who worked on the tobacco plantations in the county and in the private home in the city. Some of the slaves also worked in the tobacco factory in the business district.

The Eppes family owned several plantations in the area, including Eppington Plantation in Chesterfield County, Weston Manor and Appomattox Manor. They owned hundreds of slaves and were well established as tobacco merchants in the area.

Robert Ruffin lived on Mayfield Plantation on the Petersburg-Dinwiddie County line. The home was built around 1750 by Ruffin's great-grandfather, also named Robert. The home was passed down through the family to the **Bollings, Goodwyns, Whitworths and Wilsons.**

APPENDIX

Mary Kennon Bolling. *Courtesy of the Library of Virginia.*

The Bolling family had been in Petersburg since the mid-1600s and were already well established in the tobacco industry by 1815. Philip Bolling, a circuit court judge, had married Mary Eppes of Eppington Plantation in Hopewell. They owned several tobacco warehouses in Petersburg and lived in some of the grandest homes in the city.

APPENDIX

Robert Bolling. *Courtesy of the Library of Virginia.*

The Dunlop family had been well established in the manufacturing and exportation of tobacco products since the early 1800s. James Dunlop ran a large factory in Petersburg with his brothers Robert and David. John Dunlop, their oldest brother, ran John A. Dunlop & Co. in Louisville, Kentucky, and worked closely with the Dunlop brothers in Petersburg. The Dunlops exported tobacco products around the world, including to England, the Netherlands and Belgium. They were also owners of hundreds of slaves.

John Donald operated a tobacco plantation in Chesterfield County and manufactured tobacco products in his factory in Petersburg. He also owned several tobacco warehouses in the city.

Robert Stewart was one of the most prominent tobacco merchants in the city of Petersburg. He and his family lived in a Georgian-style mansion on High Street. Stewart owned several tobacco factories and warehouses in the city, as well as a mercantile on Old Street.

Nathaniel Friend Jr. had been the mayor of Petersburg from 1812 to 1813 and was a wealthy merchant in the city. He owned a four-story mansion on Bollingbrook Street.

Benjamin Hatcher was the first president of Farmer's Bank, related—by marriage—to the Bolling family. The first bank building was erected on Bollingbrook Street in 1812. The bank was rebuilt after the fire in 1815. Hatcher's daughter, Elizabeth, married a prominent judge in Petersburg named Nash.

APPENDIX

Roger Mallory held the office of jailer and justice of the peace in Petersburg after a distinguished career in the Continental army. He married Elizabeth Spencer Sharpe, the daughter of a very prominent planter in Louisa County, Virginia, in 1813. Roger and Elizabeth Mallory owned a grand home in the city in 1815, but she died in childbirth three months before the fire, on April 14, 1815. She was laid to rest in Blandford Cemetery.

The Boisseau family was very prominent in Petersburg by 1815. They owned a large tobacco plantation in Dinwiddie and over fifty slaves. James Boisseau ran a successful tobacco mercantile shop on Old Street with Thomas Gary, "Gary and Boisseau's Mercantile," and Robert Boisseau lived on the plantation in Dinwiddie as the overseer. As a side note, James Boisseau was killed in a duel with Robert C. Adams on Wednesday, August 9, 1820, in the Blandford area of Petersburg and is buried in Blandford Cemetery.

Henry Randolph was the great-grandson of William Randolph of Westham Plantation. The Randolph family owned thousands of acres of land throughout Virginia and over two thousand slaves altogether. The slave labor enabled the Randolphs to become extremely wealthy through tobacco cultivation in Virginia. Henry had inherited a very large estate and operated a tobacco mercantile in Petersburg. He also owned numerous tobacco warehouses.

Thomas Bott was the great-grandson of the Thomas Bott who settled a large plantation in Chesterfield County in the early 1700s. Bott married the great-granddaughter of Peter Jones and had a son, John Bott, who was born in Petersburg in 1811. The Bott family owned a plantation in Amelia County and another in Chesterfield. He was listed as owning thirteen slaves on the plantation in Chesterfield and another dozen in Amelia, as well as some who operated his tobacco plant in Petersburg.

John Hinton was a prominent physician in Petersburg in 1815. John and his brothers, Lewis, Spencer and William, all served in the Revolutionary War. The Hintons had spread out over several areas of Virginia and Kentucky after the war. Dr. Hinton was considered one of the most important doctors in the city of Petersburg in the late 1700s and through the mid-nineteenth century. His son, John, also became a physician, serving the citizens of Petersburg.

APPENDIX

Patrick Magruder was born in 1768 in Rockville, Maryland, and studied law at Princeton. He served as a Republican to the Ninth Congress from 1805 to 1807 and was a clerk of the House of Representatives from 1807 until January 1815. In the summer of 1815, Mr. Magruder was the justice of the peace for the city of Petersburg. He employed William Stark as his deputy sheriff and appointed Mr. Mathew E. Parish to run the jail in the city.

Mr. David Anderson was a respectable merchant, member of the Common Hall in Petersburg and founder of the Anderson Seminary on Washington Street.

Mr. Russell Hill was one of the most well-respected and wealthy tobacco merchants in Petersburg. He operated a plantation in Chesterfield County and owned several dozen slaves. He married Margaret Pollard in 1811, and they lived in a large home on Bollingbrook Street.

Ebenezer Stott was an attorney who ran a law office in Petersburg with Mr. James Watson, Watson and Stott, Attorneys at Law. He also owned a mercantile in Petersburg where he advertised "negro cottons, linens, ladies hats and shoes, silk, buttons, shoe hammers, &c." Stott was born in Scotland in 1766 and moved to Petersburg in 1784. He married Miss Elizabeth Phile, daughter of a wealthy tobacco planter in Dinwiddie. Mr. Watson died in 1810, and Mr. Stott continued to run the law office independently. Stott, his wife, children and Elizabeth's spinster sister, Harriet, lived in a grand mansion on High Street in Petersburg. They owned at least half a dozen slaves who ran the household for them.

Patrick Mackie, from Aberdeen, Scotland, immigrated to Petersburg in 1706 and became a respectable tobacco merchant in the city. He married Mary Gilmore in 1707, and the couple had several children. Their son, John, born in 1711, died on October 11, 1730, after a prolonged illness and is buried in Blandford Cemetery. Dr. Robert Mackie, the grandson of Patrick and Mary Mackie, was a prominent physician in Petersburg in the summer of 1815. He ran for mayor in 1808 but did not win.

APPENDIX

Slave Database in Petersburg in 1815

A great number of Petersburg residents owned slaves in 1815. Most slaves took their master's surname. In 1815, the following residents owned the respectively named slaves:

Mr. Seth Herfof owned Bertha, a twenty-year-old woman, in 1808 who was a field hand and also worked around his house.

Mr. John Davis owned ten slaves: Patt, Plato, Fanny, Frank, Patrick, Sally, Frederick, Parker, Rose and Moses.

William Johnston owned Billy.

Colonel William Call owned Ned, whom he later sold to Daniel Campbell.

Mrs. Jane B. Hardy owned a slave named Ben, whom she described as "a good fiddler."

John R. Brewer, who owned Brewer's Tavern, held slave auctions at his tavern from time to time. He purchased several slaves whom he sold to Mr. William Dunivant and Mr. John Cox on April 6, 1807, including George, Peter and Jack.

Mr. George Robertson owned six slaves: Sam, Will, Ned, Silvey, Letty and her baby, Adam.

John Bell owned a mulatto named Charles.

David Robertson owned John. He sold John to James Crichton in 1806.

Archibald Dunlop owned a slave named John who was his stagecoach driver.

Benjamin Watkins of Dinwiddie owned George, a thirteen-year-old boy, whom he sold to Leonard Crowder in 1806. George escaped after being purchased and was last seen on Pocahontas Island but was never recaptured.

Peter Bland owned Tom, Phil, Lucy, Gilbert, Ross, Maria and Dilcy. They were all auctioned off in March 1808 and purchased by Francis Fitzgerald.

APPENDIX

William Alexander owned Jesse.

Mr. Robert Donald died in January 1812. On Friday, April 17, 1812, his thirty slaves were auctioned at the Petersburg slave market. Dr. Thomas Augustus Taylor purchased four of the slaves: a man, two women and a little boy. The slaves were not named in the document.

Mr. William Cole owned Phil, whom he sold to Reuben Vaughan of Lunenburg County in June 1807.

Mr. William Munford rented out twenty-five slaves from his Richland Plantation to work in the tobacco warehouses in Petersburg for a year.

Mr. Edward Watkins brought fifteen "Virginia born slaves" to Petersburg's slave market on December 6, 1808, and sold all of them.

Mr. E.O. Goodwyn, an attorney, had slaves working in his High Street home.

Mr. Benjamin Harrison of Brandon Plantation sold a mulatto teenaged girl named Rachel to Mr. McKenzie of Petersburg in 1800. She was described as "very light skinned—will sometimes try to pass for a white woman."

Mr. William Cutler owned a fifteen-year-old mulatto boy named Billy.

Mr. Edward Dennis sold four of his slaves at the Petersburg market on November 1, 1805. They were named Ell, Lucy, Hillsborough and Matilda. Two tobacco merchants, John and William Bell, purchased all four of the slaves.

Mr. Roger Atkinson bought a slave woman named Maria on September 10, 1811, but did not purchase Maria's husband. A "great scene" erupted because Maria did not want to go without her husband.

Mr. James Harwood owned a male slave named Greenock. He sold Greenock to Hamlin Wilcox of Charles City. Mr. Wilcox later sold Greenock to Mr. Burwell Temple of Bedford County. Greenock escaped on July 26, 1811, from Temple's tobacco fields.

Mr. William Mann of Amelia County brought thirteen slaves to Petersburg on May 9, 1806, and sold them to Mr. Charles Broadfoot of Petersburg.

APPENDIX

Some of the slaves were named Ise, Lew, Daniel, Barnett, Susy, Becky, Pat and Ginny.

Bishop Madison owned a slave named Sam who escaped from him on June 28, 1812. Mr. Madison stated, "Sam will probably assume the name Sam Warrington and will attempt to pass as a free man…either in Norfolk or Richmond…he is about 35 years old, stands 5'7" and is rather robust."

Samuel Myers was originally from Baltimore, Maryland, where he helped his father and brother operate Moses Myers and Company, a merchant shipping company. Myers moved to Petersburg around the year 1790 with his wife, Rebecca Mears Hayes, the daughter of Baltimore shipping tycoon Moses Michael Hayes. Samuel and Rebecca had a son named Samuel and a daughter named Judith. Myers's shipping company in Petersburg became so lucrative that he quickly rose up the ranks as one of the most important men in the city. He owned over eighty slaves over the years, including Alice, a mulatto woman, whom he purchased in 1796, and Mordecai, whom he sold to Philip Hart of North Carolina. He purchased Jenny from Joseph Tobias of Charleston, South Carolina, for $300 and Charles for $500 in 1798. That same year, he purchased Sylvia from Solomon Raphael of Richmond and another slave named Flora, along with her children, Isaiah, Charlotte and Joseph. In 1800, he purchased Samuel, Emanuel and Moses. Most of the male slaves worked in his shipping business in Petersburg, while the women worked in the home as domestics.

Neighboring Plantations in 1815

Many of the neighboring plantations in the area rented slaves to businesses in Petersburg and shipped their tobacco, wheat, cotton and grains to Petersburg to be warehoused, processed and exported. Some of them include:

Brandon Plantation, Prince George County, owned by Robert Harrison

Tar Bay, Prince George County, owned by Nathaniel Colley

Upper Brandon Plantation, Prince George, owned by Robert Harrison

APPENDIX

Beechwood, Prince George, owned by Edmund Ruffin

Kippax Plantation, Hopewell, owned by the Bolling family

Old Poplar Grove, Chesterfield, owned by the Robertson family

Bellevue Plantation, Chesterfield, owned by Thomas Lewis

Roseberry Plantation, Dinwiddie County, owned by Peter Bland

LIST OF BUSINESSES AND HOMES DESTROYED IN THE FIRE

Old Street

Mr. Richeson and Sons, Slave Traders and Auctioneers
Mr. G.K. Taylor, Slave Trader
Residences of Mr. Cosby, Mr. Bragg, Mr. Cook, Mr. S. Davis, Mr. James Streat and Mr. Zimmerman
Tenement houses owned by Mr. Hector McNeil, Mr. Brewer, Mr. Farlamb, Mr. H. Baird and Mr. McIntosh
Office building at the corner of Old and Sycamore Streets occupied by Mr. H. Moreno, Mr. David Maben and Mr. Bryan Giffin
The Old Street Theatre
Print shop and newspaper, the *Petersburg Intelligencer*
Tenement homes owned by Mr. Hector McNeil
Row of tobacco warehouses owned by the Dunlop family
Ann Swail's Grocery
Home of Sarah Weatherly, midwife
Home of Mr. Thomas Wallace
Home of Mr. Edward Sparhwawk
Mr. Thomas Warrell's dance studio
Edward Powell's tavern
Mr. Augustino Fromento's Salon for Ladies
Powell's Tavern

APPENDIX

Sycamore Street (Walnut Street in 1815)

Mr. Cottom's Book Store
Apartment building owned by Mr. Grundy, Mr. Wells and Mr. Taylor
Apothecary of Mr. Bragg and Mr. Jones
Mr. John Williams's home
Mr. Francis Lynch's "Most Elegant" building
Tenement houses owned by Mr. D.A. Rawlings
Printer's office owned by Mr. Yancey and Mr. Whitworth
Private home of Mr. and Mrs. Lynch
Several bookstores
Yancey and Whitworth's Printers

Bollingbrook Street

Large commercial building at corner of Bollingbrook and Sycamore Streets that housed the law offices of Mr. Farrar, Mr. Boast and Mr. Wm. McCay
Three small tenement houses, unoccupied
Two new homes under construction
Private residence and grocery store owned by Elizabeth and Ann Swail
Private residence of Mrs. Sarah Thomas, midwife
Boardinghouses owned by Mrs. Geddy and Mrs. Bolling
Milliner shops owned by Mrs. Miles and Mrs. Phoebe
Private homes of Mr. Robert Bolling, Mr. David Dunlop, Mr. Nathaniel Friend and Mr. A. Mercer
Tobacco warehouses belonging to Mr. Dunlop, Mr. Bolling and Mr. Friend.
J.J. Selby and Mr. Harned's Dry Goods Store
Mr. H. Webb Dry Goods Store and private apartment above
George and Milliman's Confectionary
Mr. Pearce's Saddlery
Bennett and Thomas Watchmakers Shoppe
Mrs. Phoebe's Millinery
Mr. Justus Smith's Apothecary
Apartment of Colonel Byrne
Mr. J. Walker's Dwelling House
Wilkinson and Wells Grocers
Wm. Colquhoun's Dry Goods
Pollard's Saddlery

APPENDIX

Apartment of Mr. Lewis Zimmer
Tenement house of Mr. Frederick Williams
Lochheads and Davis' Dry Goods Store
Miss Mary Ann Bolling's Tenement House
Mr. William Cumming's office
Mr. Dancy and Mr. Gibbon's office
Mr. Sharpe's Grocery
Large manor home of Mr. John Dunlop
Mr. William Johnson's office
Mr. Frederick Williams' Grocery
Office of Mr. E.G. Blake
Home of Mr. William Davis
Home of Mr. T. Wilcox
Home of Mr. L.E. Stainback
Grocery of Mr. Charles Russell and private apartment above the store
Office of Mr. Richard Bates
Home of Mr. William Robertson
Home of Mr. M.C. Madden
Tenement house owned by Mr. William Frazer
The Columbian Hotel, under construction at time of fire
A shoemaker's shop
Home of Mrs. Ephram Geddy, a widow
Home of Mr. Benjamin Curtis
Office of Mr. George Brown and attached apartment
Mr. Littlejohn's Shoemaker Shop
Offices of Mr. Cameron and Mr. Townes
Mr. John Hart's Tinnery
Mrs. Adams' Boarding House
Dillworth and Dunnavant, Printers
Mrs. Miles Millinery Shop
Mr. J.E. Reviere Confectioner
Mr. William Robertson's Tenement House
Williams' Mercantile Shop
Mr. John Banks, Tailor
Collins' Dry Goods Store
Home of Mr. William Gilmore
Mr. Colin Alfriend's Grocery
Mr. William Cain, Tailor
Nathaniel Friend's Dry Goods Store

APPENDIX

Haxall's Vendue Office
Haxall's Lumber House
T.R. Ryan's Dry Goods Store
J.W. Campbell's Book Store
Office of Mr. Heslop
Neilson and Brewer's Grocery Store
Potter and Geise's Hardware Store
Clarke and Gordon's Dry Goods Store
Mr. Jones Mitchell's Store
Mr. William Barker's Hat Store
Mr. Pascal Wells, Tailor
Mr. John Magie's Dry Goods Store
Mr. Solomon High's Grocery
Russell Hill's Dry Goods Store
Mr. Allan Mitchell's Grocery
Pace and Cate's Grocery
James Boyle's Grocery
Office of Mr. Samuel Turner and the apartment above the store
John Wright and Co. Shoe Store
Follet and Lea's Hardware
J. and E.F. Smith's Grocery
Turner and Goodwin's Grocery
James Boisseau's Grocery
Pride's Shoes
Mr. E. Canterbury's Grocery
Mr. Frazer's Grocery
Mr. Fisher's Hat Shop
The lumber houses at the end of Bollingbrook Street

Bank Street

The bank and exchange building
Mr. John Gowan's Grocery
Private homes of Mr. Love, Mr. Traylor and Mr. Simmons

APPENDIX

Back Street

Boardinghouses owned by Dr. William Moore
Private homes of Mr. Kendall, Mr. Thomas Rosser, Mr. Armistead, Mr. Peter McCullock, Mr. Cabiness, Mr. Dennis, Mr. Smith and Mr. Cuthber
John Hinton's Grocery and private apartment building he owned above the store
Private home and office of Mr. Theo Trezvant
The Back Street Theatre
The Virginia Inn, owned by Mr. John Worsham
A silversmith shop
The Westbrook Warehouse
Lumber houses owned by Mr. Heslop, Mr. Colquhoan and Colonel Byrne
The Merchant's Hall and apartments above the Merchant's Hall occupied by Mr. Blake and Mr. Thweatt
Boardinghouse for young apprentices
St. Paul's Church and the home of Reverend Syme, attached to the church
Private home of Mr. P. Suit
John Davis' Distillery
The Market Square
The Market House
The Slave Auction House
Allan Mitchell's Grocery
Office of Samuel Turner, Esq.
John Wright, Shoemaker
Turner and Goodwin Grocers
James Boisseau's Grocery
Canterbury's Grocery
Moore and Love's Wholesale and Retail Druggists
Frances Lynch's Hat and Bonnet Shop
Richard Cocke's Stagecoach Line office
Thomas Neilson's Dry Goods Distillery

High Street

Grain Mill
Milk bottling plant
Butcher shop

APPENDIX

Samuel Stephens Shoemaker
Joseph Swan's Bookbindery
The Iron Foundry
Dunlop Tobacco Warehouses
Samuel Myer's Shipping Merchant's office
Several tenement homes owned by Mr. Samuel Myers
High Street Coachmakers
A gunsmith shop
Luxury Furniture and Silver Goods
The Green Grocers
Fresh fruit and vegetable shop
Confectionery and bakery

BIBLIOGRAPHY

Friend, William Nathaniel. *A Social History of Petersburg, Virginia*. N.p.: Petersburg Publishers, 1800.

Pollack, Edward. *Historical & Industrial Guide to Petersburg, Virginia*. N.p.: Petersburg Publishers, 1884.

Price, James. *Virginia: A Guide to the Old Dominion*. N.p.: Oxford University Press, 1941.

Seagrave, Ronald Roy. *Early Artisans & Mechanics of Petersburg, Virginia*. Denver, CO: Outskirts Press, 2010.

Smith, Geddeth. *The Brief Career of Eliza Poe*. Madison, NJ: Fairleigh Dickinson University Press, 1988.

Smith, James Wesley, and Martha S. Dance. *The History & Legends of Pocahontas Island*. VA: L.R. Valentine Publishers, 1981.

INDEX

A

accidental deaths 49
Adams Boarding House 40
African Americans 29, 30, 31, 76, 77
Alfriend's Grocery 40, 91
Algonquian language 19
All American City 71
American Revolution 22, 30, 58
Anglican Church 51
Anna P. Bolling Junior High School 76
Appomattox 19, 20, 21, 29, 30, 32, 38, 49, 56, 57, 71, 72, 74, 75, 81
Appomatuck 19
apprentices 34, 36, 38
Arnold, Benedict 20
Artillery Fencibles Company 63
Atlantic, Mississippi & Ohio Railroad 74

B

Back Street 38, 40, 54, 55, 65, 66
Back Street Theatre 40, 42, 43, 44, 93
Bank Street 22, 25, 26, 32, 38, 40, 55
Bates, Richard (lawyer) 40, 91
Beechwood Plantation 24, 89
Bennett and Thomas Watchmakers 90
Blake, E.G. 40, 91
Blandford Cemetery 28, 34, 37, 45, 47, 63, 78, 84, 85
Blick, George 44, 45
Blick, Milleson 44, 45
Boisseau family 27, 84
Boisseau's Grocery 40, 92, 93
Bollingbrook Hotel 67
Bollingbrook Street 21, 29, 30, 39, 40, 46, 54, 55, 61, 62, 65, 66, 85, 90, 92

INDEX

Bolling family 21, 22, 24, 27, 61, 89
Bolling, John 29
Bolling, Robert 22, 23, 37, 90
Bolling Tenement House 40, 91
Bott, John 84
Bott, Thomas 23, 84
Boyle's Grocery 40, 92
Bragg and Jones' Apothecary 40, 90
Brandon Plantation 24, 87, 88
Brewer's Tavern 66, 86
Brown, George (lawyer) 40, 91
Brown & Williamson Tobacco 72, 77
Burke, John 47
Burk, John (teacher) 33
Burr, Aaron 43
business district 24, 38, 39, 44, 58, 62, 81
Byrd, Colonel William 19

C

Cain Tailor Shop 40, 91
Cameron and Townes, Lawyers 40, 91
Campbell's Book Store 40, 92
Camp Lee 76, 77
Canterbury's Grocery 40, 92, 93
Cedar Grove Cemetery 47
Central Lunatic Asylum 76
Centre Hill 22
Chesapeake, The 66
Chesterfield County 15, 26, 29, 63, 71, 77, 81, 83, 84, 85
child labor 36, 38
City Point Railroad 71
Civil War 70, 71, 73, 74

Clark, Ann (headmistress of Petersburg Female Academy) 34
Clarke and Gordon's Dry Goods Store 40, 92
Classical Institute 75
coachmakers 94
Cockade City 21
Cocke Stagecoach Lines 40
Cocquebert, Felix 47
Collins Dry Goods 40
Colson, Colonel William 29, 30
Columbian Hotel 40, 91
coroner 46
Cottom's Book Store 40, 90
courthouse 22, 23, 43, 45, 67, 69
crime 43, 45, 47, 48
　domestic disturbances 44
　duels 47, 84
　highwaymen 46
　highway robbery 46
　horse theft 44
　infanticide 48
　kidnapping 48
　mail coach robbery 46
　muggings 44
　murder 48
　robberies 44
　suicides 46
　vagrancy 38, 46
　whipping post 28, 43, 45
Cummings, William (lawyer) 40

D

dame schools 34, 75
Dancy and Gibbons Mercantile 40, 91

INDEX

Davis' Distillery 40, 93
Davis, John 86
Davis, William 45, 91
Dickson, John 39
Dillworth and Dunnavant, Printers 40, 91
Dinsmore, James 69
Dinwiddie Academy 34
Dinwiddie County 15, 19, 24, 63, 81, 89
Duncan M. Brown Grammar School 75
Dunlop, Archibald 86
Dunlop, David 24, 83, 90
Dunlop, John 37, 83
Dunlop, Mary Ruffin 37
Dunlop, Robert 24, 83
Dyde, Mr. 45

E

East Hill 22
Elebeck, Henry 29
Episcopal School for Boys 34
Eppes family 27, 81, 82
European Enlightenment 51
exports 38, 57, 58

F

Farmer's Bank 40, 78, 83
Farrar, Boast and McCay, Attorneys at Law 40, 90
film industry 78
Fisher's Hat Shop 40, 92
Fleet's Hill 47, 56
Fleming, John 45
Follet and Lea's Hardware 40, 92
Fort Henry 19
Frazer's Grocery 40, 92
free blacks 29, 30, 31, 32, 44, 53, 76
Friend, Nathaniel 69, 83, 90
Friend's Dry Goods Store 40, 91
Fromento, Augustino 40, 89
funerals 63, 64, 65, 76
furniture makers 22, 59

G

Geddy, Mrs. Ephram 40, 62, 90, 91
Geddy's Estate Auction 40
general assembly 29
George and Milliman's Confectionary 40, 90
Gill, Erasmus 69
Gillfield Baptist Church 29, 53, 77
Golden Ball Tavern 39, 41
Gowan's Grocery 40, 92
Green, Lewis 23

H

Haffey, Roderick 22
Haitian immigrants 31
Halfway House 71
Hall, Arthur 23
Hart's Tinnery 40, 91
Haxall's Lumber House 40, 92
Haxall's Vendue Office 40, 92
High Street 16, 21, 22, 41, 83, 85, 87, 93
Hinton, John 84, 93
Hinton's Grocery 40, 93
Howlett's Tavern 71

INDEX

I

infant mortality rate 37
influenza epidemic 75
insurance 54, 61, 66, 67

J

jail 22, 43, 46, 69, 85
Jarratt, Alexander 31
Jarratt, Richard 31
J.C. Penney 77
Jeffers, John 47
Jefferson Davis Highway 71
Jefferson Davis Punch 74
Jim Crow laws 76
Johnson, John 47
Johnson, William (lawyer) 40, 91
Jones, Peter 19, 23, 80, 81, 84
Justus Smith's Apothecary 40, 90

K

Kinchen (child slave) 30
King George I 32
King, Martin Luther, Jr. 77

L

Lailson's Circus 42
Landsdill, Nancy 48
Lieutenants Run 22
Littlejohn's Shoes 40, 91

Lockett, Lucy 28
Longstreet's Café 32
Lynch's Hat and Bonnet Shop 40, 93

M

Mahone, General William 74, 76
Mallory, Elizabeth 37, 84
Mallory, Roger 37, 84
market square 26, 32, 40, 55, 93
Market Street 22, 24, 80
Marquis de Lafayette 20
McIlwaine, Archibald 69
McKenna, William 23
McNeil, Hector 39, 89
Merchant's Hall 93
Miles Millinery 40, 91
milk bottling plant 16, 41, 61, 93
Mitchell's Mercantile 40
Moore and Love's Wholesale and Retail Druggists 40, 93
Moore's Auction House 24
Moore's Boarding House 40
Morales, Anthony 45
Mordecai, Mrs. Jacob 34, 35
mulattoes 30
Murford, Robert 23
Myers, Samuel 56, 63, 64, 88, 94

N

National Gazette 62
National Park Service 73
Neilson and Brewer's Grocery 40, 92
Neilson, John 69
Neilson's Dry Goods Store 41, 93

INDEX

Nelson, General Thomas 20
New Blandford 21
Newsum, John (teacher) 33, 34
New Town 22
New Towne 21
Niles Weekly Register 65
Norfolk and Petersburg Railroad 71, 74
Norfolk and Western Railway 74

O

Oak's Tobacco Warehouse 24
Old Blandford 21
Old Street 25, 26, 32, 39, 40, 42, 55, 83, 84, 89
Old Street Fire Brigade 17, 54
Old Street Theatre 40, 42, 69, 89
Old Town 21, 22, 23, 37, 73, 78
Old Towne 21
orphans 37, 38

P

Pace and Cate's Grocery 40, 92
Parish, Deputy Sheriff Mathew E. 43, 85
Patterson's Grocery 40
paved streets 39, 66, 69, 71
Peabody High School 76
Pearce's Saddlery 40, 90
Pegram, John 44
Peniston, John 30, 61
Petersburg Bus Terminal 77
Petersburg Female Academy 34
Petersburg Female Orphan Asylum 38
Petersburg High School 75, 76
Petersburg Intelligencer 26, 34, 35, 39, 44, 45, 47, 48, 55, 59, 89
Petersburg Mutual Insurance Company 61
Petersburg National Battlefield 73
Petersburg Poorhouse and Orphan Asylum 38
Petersburg Theatre 69
Petersburg Volunteers 21, 22
Peter's Point 19
Phile, Elizabeth 37, 85
Phillips, General William 20
Phoebe's Millinery 40, 90
Pocahontas (Indian princess) 19, 29
Pocahontas Island 21, 29, 30, 31, 32, 46, 53, 80, 86
Poe, Edgar Allan 43
Poe, Eliza 42
Poindexter, John 48
Pollard, Calvin 67
Pollard, Margaret 85
Pollard's Saddlery 40, 90
Potter and Geise's Hardware Store 40, 92
poverty 45
Powell, Edward 39, 89
Powhatan, Chief 19
Powhatan Confederacy 19
Pride's Shoes 40, 92
public school system 32

R

Randolph family 27, 61, 84
Ravenscroft 21, 22
Richeson and Sons Slave Traders 25, 89

INDEX

Roberts, Joseph Jenkins 29, 30
Robertson family 89
Rolfe, John 29
Roseberry Plantation 24, 89
Rucker-Rosenstock's 77
Ruffin family 27, 61, 81, 89
Ryan's Dry Goods 40, 92

S

Sandy Beach Church 29, 31
schools 15, 32, 33, 34, 35, 36, 59, 75, 76, 77
Sears 77
Selby and Harne's Dry Goods Store 40, 45, 90
Shakers 63
Sharpe's Grocery 40, 91
Siege of Petersburg 72, 73
Simon's Circus 42
slaves 23, 24, 25, 26, 27, 28, 29, 30, 31, 32, 33, 42, 51, 52, 53, 57, 66, 81, 83, 84, 85, 86, 87, 88
 auctions 25, 32, 87
 corporal punishment 35
 escaped and runaway 26, 28, 32, 47
 insurrections 48, 66
 patrols 47
 pens 25
 punishment 28
Smith, John 19
Smith, Jonathan (teacher) 33
Smith's Grocery 40, 92
Society of Believers 63
Southern Christian Leadership Conference 77
Southern Female College 75

Southpark Mall 78
Southside Railroad 71
Stark, William 43, 85
starvation balls 74
Stephens Shoe Shop 41, 94
Stewart family 27, 61, 83
Stonewall Jackson Grammar School 75
Stott, Ebenezer 37, 85
Stott, Helen 37
St. Paul's Episcopal Church 22, 34, 67
Sunday dinner 52
Swail, Ann 37, 39, 89, 90
Swail, Elizabeth 37, 39, 90
Swan's Book Binding 41
Sycamore Street 22, 29, 38, 40, 42, 55, 63, 75, 77, 89, 90
Syme, Reverend Andrew 34, 93

T

Tabb Street 24
Tabb Street Presbyterian Church 67
Taylor, G.K. (slave trader) 25, 89
Thalhimer's 77
Thrift, Reverend Minton 34
tobacco 21, 22, 23, 24, 25, 26, 28, 29, 31, 32, 36, 38, 39, 40, 41, 44, 51, 55, 57, 58, 59, 69, 72, 73, 81, 82, 83, 84, 85, 87, 88, 89, 90, 94
Treadway, Mrs. (school matron) 38
Trippe, Andrew 66
trolley system 72
Turner, Samuel 40, 92, 93
Tutbell, Susan 48

INDEX

U

Union army 73, 74

V

Virginia and Tennessee Railroad 74
Virginia Electric and Power Company (VEPCO) 72
Virginia Inn 40, 93
Virginia Normal and Collegiate Institute 76
Virginia State University 76

W

Walker, John 54, 65, 66, 90
Walker, Wyatt 77
Wallace, Thomas 39, 89
Walnut Mall 78
War of 1812 21, 22
Warrell, Thomas 39, 42, 89
Washington, General George 20
Washington Street 33, 34, 75, 77, 85
Weatherly, Sarah (midwife) 37, 39, 89
West, Ann 43
Westbrook Tobacco Warehouse 40, 93
West Hill 22
West Hill Warehouse 24
West, Thomas 43
Wilkinson and Wells Grocers 40, 90
Williams' Grocery 40, 91
Williams, Louise 45, 46
Williams' Mercantile 40, 91
Wittontown 29

Woolworth's 77
World War I 76
World War II 77
Wright and Co. Shoe Store 40, 92, 93

Y

Yancey and Whitworth Printers 40, 90

ABOUT THE AUTHOR

Tamara Eastman has made it her life's goal to work in the field of history. She has served as a tour guide for the city of Petersburg for several years, spent over a decade as a living historian portraying a seventeenth-century midwife and tobacco farmer's wife and writes history books. Her first book, *The Pirate Trial of Anne Bonny and Mary Read*, chronicles the story of two of history's most infamous female pirates—made so merely because they were the only two ever captured alive and put on trial in the eighteenth century.

Eastman is also a filmmaker, presently directing *Insurrection*, which is being filmed in Petersburg, Virginia, and getting ready to embark on a feature film, *Gallows Bait*, that will be shot on location in England in 2016.

Eastman, by day, is a military historian for the Department of Defense, the Defense Commissary Agency, headquartered at Fort Lee, Virginia. She holds a master's degree in history from Virginia State University in Petersburg, Virginia, and is working on a post-graduate degree in mass media and film at Virginia State.

She lives in Dinwiddie County, Virginia, with her Pomeranian, Cherie.

*Visit us at
www.historypress.net*

This title is also available as an e-book